Adorno Reframed

Contemporary Thinkers Reframed Series

Adorno Reframed ISBN: 978 1 84885 947 0
Geoff Boucher

Agamben Reframed ISBN: 978 1 78076 261 6
Dan Smith

Badiou Reframed ISBN: 978 1 78076 260 9
Alex Ling

Bakhtin Reframed ISBN: 978 1 78076 512 9
Deborah Haynes

Baudrillard Reframed ISBN: 978 1 84511 678 1
Kim Toffoletti

Deleuze Reframed ISBN: 978 1 84511 547 0
Damian Sutton & David Martin-Jones

Derrida Reframed ISBN: 978 1 84511 546 3
K. Malcolm Richards

Guattari Reframed ISBN: 978 1 78076 233 3
Paul Elliott

Heidegger Reframed ISBN: 978 1 84511 679 8
Barbara Bolt

Kristeva Reframed ISBN: 978 1 84511 660 6
Estelle Barrett

Lacan Reframed ISBN: 978 1 84511 548 7
Steven Z. Levine

Lyotard Reframed ISBN: 978 1 84511 680 4
Graham Jones

Merleau-Ponty Reframed ISBN: 978 1 84885 799 5
Andrew Fisher

Rancière Reframed ISBN: 978 1 78076 168 8
Toni Ross

Adorno

Reframed

Interpreting Key Thinkers for the Arts

L **Geoff Boucher**

I.B.TAURIS

Published in 2013 by I.B.Tauris & Co. Ltd
6 Salem Road, London W2 4BU
175 Fifth Avenue, New York NY 10010
www.ibtauris.com

Distributed in the United States and Canada Exclusively by
Palgrave Macmillan 175 Fifth Avenue, New York NY 10010

ISBN: 978 1 84885 947 0

A full CIP record for this book is available from the British Library
A full CIP record for this book is available from the Library
of Congress

Library of Congress catalog card: available

Typeset in Egyptienne F by Dexter Haven Associates Ltd, London
Page design by Chris Bromley
Printed and bound by CPI Group (UK) Ltd, Croydon, CR0 4YY

Contents

List of illustrations vii

Preface and acknowledgements ix

Introduction: Atonal philosophy 1

Chapter 1. Negative dialectics 31

Chapter 2. Adorno's history of modernism 62

Chapter 3. Aesthetic theory 94

Chapter 4. Adorno today 126

Further reading 153

References 157

Index 165

List of illustrations

Figure 1. Pablo Picasso, *Guernica* ©Pablo Picasso/
Succession Picasso. Licenced by Viscopy, 2011. 9

Figure 2. Still from *The Cabinet of Dr Caligari*,
Rights: Friedrich-Wilhelm-Murnau-Stiftung;
Distributor: Transit Film GmbH. 27

Figure 3. Giuseppe Pellizza da Volpedo, *Il quarto stato*,
Museum of the Twentieth Century, Milan
'Copyright City of Milan – all rights reserved in law'
©Photoservice Electa, Milan/Luca Carra. 37

Figure 4. Wassily Kandinsky, *Composition VII*
©Wassily Kandinsky/ADAGP. Licensed by Viscopy, 2011. 84

Figure 5. Wassily Kandinsky, *Composition VIII*
©Wassily Kandinsky/ADAGP. Licensed by Viscopy, 2011. 88

Figure 6. Emil Nolde, *Tanz um das Goldene Kalb*
©Nolde Stiftung Seebuell. 91

Figure 7. Anselm Kiefer, *Himmel auf Erden*
©Anselm Kiefer. 101

Preface and acknowledgements

Theodor Adorno is one of the most provocative and important, but least understood of contemporary thinkers. Yet despite the fact that Adorno is one of the only important contemporary philosophers to have published a theory of aesthetics, his influence in the arts has been severely limited by the perception, shared unfortunately by some commentators, that his is a merely negative position. *Adorno Reframed* not only frames Adorno for an audience coming to his aesthetic theory for the first time, through the medium of detailed discussion of particular artworks and pieces of music, but also reframes Adorno as a utopian thinker rather than a bleak pessimist. Drawing on new scholarship, *Adorno Reframed* challenges the popular image of the miserable elitist without in any way domesticating Adorno for the world of the multinational entertainment corporations. This Adorno is a supporter of late modernism, and a defender of the idea that aesthetic experience offers a real alternative to corporatised forms of human existence.

The world of Adorno scholarship in English has benefited in the last two decades from a series of vastly improved translations of Adorno's works, and I have relied on these as much as possible in this book when quoting. The exception is *Negative Dialektik*, for which I have provided my own translations; readers who use the E.B. Ashton translation of *Negative Dialectics* need to be aware that many terms of Hegelian philosophy and Marxist sociology are rendered into English in extraordinary ways. I have quoted from

this work with the German page reference first, followed by the translated one.

I wish to thank Deakin University for its grant under the Outside Studies Placement scheme, which made possible six months of research for this book. I also wish to thank the department of Philosophy at Macquarie University for generously hosting me during this period. Nicholas Smith, Jean-Philippe Deranty, Robert Sinnerbrink and Heikki Ikaheimo made excellent discussion partners during the process of thrashing out basic ideas, and I thank them for these spirited debates. Dialogue with Pieter Duvenage and Johann Rossouw on Adorno and Habermas was extremely illuminating, and many conversations with Matthew Sharpe on Critical Theory have enabled me to clarify the positions expressed here in a multitude of ways. Grace Jefferson and Matthew Sharpe kindly read and commented on the manuscript; all remaining confusion is mine alone.

Introduction

Atonal philosophy

The Prince of Darkness is a gentleman of refined sophistication and exquisite tastes. We know this because that emissary of Lucifer, the archfiend Mephistopheles, told us so, in English in Marlowe's *Doctor Faustus* and then in German in Goethe's *Faust*. But when the Devil finally presents himself in Thomas Mann's *Doctor Faustus* (1947), it is as a vicious pimp, in tight pants, yellow shoes and a cheap jacket. In the book's central confrontation between the Devil and the avant-garde composer, Adrian Leverkühn, however, the Devil manages to morph briefly into a sartorial professor. Emanating a powerful aura of absolute coldness, the Prince of Darkness delivers a devastating critique of modern music. That figure is, of course, none other than Theodor W. Adorno – avant-garde composer, dialectical philosopher, radical critic, and 'musical advisor' in the writing process of Mann's novel about the rise of fascism. 'The masterpiece,' says Adorno-as-the-Devil, 'the self-sufficient form, belongs to traditional art; emancipated art rejects it … for the historical movement of the musical material has turned against the self-contained work' (Mann, 1968: 232–33).

In Mann's novel, the Devil's advice assists Leverkühn to achieve artistic greatness at the expense of human solidarity. In desperate loneliness, Leverkühn breaks from classical music, with its organic forms and harmonious intervals. He invents a new, atonal music that combines rigorous technical constraints with unprecedented expressive possibilities. As death and madness invade the shrinking circle of Leverkühn's damaged life, his final composition

– *The Lamentation of Doctor Faustus* – represents an atonal 'retraction' of Beethoven's *Ode to Joy*. This is the twentieth century's bleak response to the nineteenth century's optimistic vision. Technological advance and scientific progress have not brought happiness, but rather enslaved the individual to anonymous systems and political demagogues. Progressive technique and rational mastery of the musical material have not yielded songs of delight, but only the perfected means to express the suffering of Leverkühn's arctic solitude. The German intellectuals, Mann suggests, sold their souls to the devil of fascism when they turned their backs on the ideals of liberalism and the humanist tradition. They rejected the humanist ideal of the organic work of art, and embraced either an arid avant-garde idea of progress (Leverkühn) or a reactionary nostalgia for authoritarian collectivism (Leverkühn's opposite, Breisacher, modelled on the composer Stravinsky).

Not surprisingly, the models for Leverkühn and the Devil, themselves also in exile from fascism in the United States during the 1940s, and indeed living in Hollywood not far from Mann, were unimpressed – but for rather different reasons. Arnold Schönberg, the Viennese composer, who in reality developed the forms of atonal music that the character Leverkühn discovers, was eventually credited for his invention by Mann in the second edition. But Schönberg could never forgive the representation of the avant-garde composer as forging an aesthetic breakthrough by morally irresponsible means, through coldness and calculation. As it happens, in 1947 Schönberg brought out an important work of his own that was anything but unfeeling (Schmidt, 2004). The seven minutes of *A Survivor from Warsaw* are a lamentation not for the German intellectuals but for the Jewish victims. It ventilates what Adorno described as 'anxiety, Schönberg's expressive core, [through] identification with men in the agonies of death, under total domination' (Adorno, 1967a: 172).

Adorno, meanwhile, had more reasons than Schönberg to be upset about attribution. Most of the extensive musicology in *Doctor Faustus* was taken – often almost verbatim – from the manuscript of his *Philosophy of Modern Music*, which Adorno had lent Mann before its publication, also in 1947. Characteristically, Adorno was unconcerned about intellectual property. He was disturbed by what he felt to be Mann's betrayal of 'the utopia of youth, the dream of a world unspoilt' (Gödde and Sprecher, 2006: 10). Mann's is an incipient Cold War ideology, nostalgic for the golden age of bourgeois society. Appalled at what fascism had revealed about the fragility of democracy, and devastated by the catastrophe of revolutionary hopes in Stalinist totalitarianism, Mann proposes that even the imagination of a better world is irresponsible (Gödde and Sprecher, 2006: 93). Adorno was a lifelong, bitter critic of Stalinism. He described Stalinist totalitarianism as 'state capitalism', and refused to concede that the Soviet Union had anything whatsoever to do with socialism. But by contrast with Mann, Adorno thinks that the disaster of fascism in Germany was not because the intellectuals had abandoned humanism and liberalism, but because liberal humanism had ceased to be historically effective. Capitalism is both dehumanising and anti-liberal, Adorno argues: capitalism undermined liberal humanism and generated the conditions that made fascism possible.

Adorno's *Philosophy of Modern Music* is the companion piece to his collaboration with Max Horkheimer, *Dialectic of Enlightenment*, yet another work produced in 1947. The *Dialectic of Enlightenment* sets out to clarify the real causes of totalitarian domination. The scientific rationality of the European Enlightenment aimed at liberating humanity from natural want and the religious superstition that went with it. But this goal of the mastery of nature became, when Enlightenment rationality combined with capitalist society, a means for the domination of men and women. When rational

calculation is placed in the service of an economic system that regards everything in monetary terms, it must quantify and evaluate, must treat its objects, including human beings, as things. It must reify them. For Adorno, the capitalist society that in the eighteenth century liberated individuals, providing them with social prosperity, political rights and liberal ideas, in the twentieth century became dominated by a totalitarian state, became an administered society that dispensed with liberal politics and human rights. Eventually, the methodological techniques of Enlightenment rationality became a social procedure: thanks to the perfected calculations of the Nazi's administrative apparatus, nothing was wasted; they even remembered to use the pubic hair of exterminated victims to make thicker socks for the U-boat crews (Distel and Jukusch, 1978: 137). Social progress through technological advances and human happiness through market mechanisms – these became the new myths of the Enlightenment. The myth of technological progress then generated dark counter-myths of blood and soil, solidarity through sacrifice of the individual and savage release through primitive regression.

Horkheimer's companion piece is *Eclipse of Reason*, published – when else? – in 1947, and it explains the intent behind the idea of a critique of the tragedy of enlightenment. The alternative to the scientific positivism of Enlightenment rationality is not the abandonment of reason. The alternative is a renovation of humanist ideals within the framework of a different conception of reason (Horkheimer, 1974: 128–51). An alternative rationality must grasp reason historically, while understanding the social conditions of political freedom (Horkheimer, 1974: 182–84). Adorno's central contribution to this project is to suggest that art and culture are the most important parts of this alternative rationality. Trained as a composer of avant-garde music, Adorno believes that modernist art does not at all surrender to dehumanisation, but instead vigorously

protests against it. As one of the twentieth century's most important philosophers, he locates modernism's protest in its social and intellectual context, as an act of resistance against the reifying effects of capitalist economics and its calculating rationality. But Adorno is also critical of some kinds of modernism. Modernism, for Adorno, has two wings: a radically utopian and progressive wing, that speaks the truth to power, and a reactionary and nostalgic wing that rejects rationality altogether and embraces fascist collectivism.

Mann and Adorno therefore approach the questions of the significance of modernism and the origins of fascism from diametrically opposed perspectives. That explains their completely different evaluations of Schönberg/Leverkühn. For Mann, all of modernism reflects a morally irresponsible intellectual and aesthetic decision. For Adorno, Schönberg/Leverkühn and Stravinsky/Breisacher reflect a social and historical process. For Mann, fascist totalitarianism is the opposite of liberal democracy. For Adorno, fascist totalitarianism emerges because of the historical limitations of liberal democracy. This could not fail to strike Mann as 'daemonic'.

Adorno as the Devil

Adorno as the Devil – the image is striking. Again and again, it has captured the imaginations of those who need to represent Adorno's modernism as a problem. But every culture involving domination, as Adorno knew well, needs a demonology.

Theodor W. Adorno (1903–69) is, quite simply, the twentieth century's most important philosophical spokesperson for the legitimacy of artistic modernism, as a politically and aesthetically radical breakthrough. Adorno once said that the problem with philosophical aesthetics is that it usually lacks one of two important things – the philosophy, or the aesthetics. Adorno had both. A highly original philosopher, his work is central to the very unorthodox current of Western Marxism known as Critical

Theory, or the 'Frankfurt School'. A gifted musician, Adorno had studied composition under the avant-garde composer of atonal symphonies, Alban Berg, and written a wildly experimental opera on the theme of *The Treasure of Indian Joe* (based on Mark Twain's *Tom Sawyer*). An assimilated Jew forced to flee Hitler's Germany, Adorno's philosophical interventions identified the fascist potentials in German existentialism (especially Martin Heidegger) right from the 1920s. A passionate advocate of political freedom and moral independence, artistic integrity and what he called 'reconciliation' amongst human beings and with the natural environment, Adorno's Marxist individualism is the enemy of all forms of totalitarianism, Nazi or Stalinist. He insisted that aesthetics and philosophy be responsible to the major questions posed by history, investing sometimes extravagant hopes in the power of groundbreaking art and dialectical thought to loosen up petrified cultural conventions and rigid ways of thinking. His interpretations of music, literature, painting and theatre advocate a dissonant modernism that complements Adorno's radical politics. Meanwhile, his critiques of mass culture, of radio and television, newspaper astrology and mainstream sport, popular music and airport fiction, link the entertainment industry to widespread apathy. He loved Kafka's idea that unconventionality is 'an axe, with which to break up the frozen sea within', but he wielded the cutting edge of art and philosophy as a scalpel.

Yet surprisingly, Adorno is completely unwelcome in some areas of academia today. We are currently experiencing an era of cultural populism. The totality of the entertainment products of the multinational corporations is sometimes uncritically regarded, especially within media and cultural studies, as the only legitimate culture. In this context, Adorno's searing analyses of the 'culture industry' are highly unpopular. Introductions to these fields regularly treat Adorno with the respect normally accorded to a dead dog. Supposedly, the features of his works are locked into a

ferocious grimace about the commodification of culture; that is, the advent of markets in the art world. Authorities in media studies have dismissed him as the author of the 'injection theory' of media effects, a position whose clinical stupidity, if truly held by Adorno, would be grounds for expressions of pity rather than shrills of outrage. Brandishing Adorno's misunderstood essays on jazz, experts in cultural studies have regarded him as a hopeless case, the 'doleful dialectician of the Frankfurt School', an elitist cultural watchdog, snarling at the epoch of mass society. The reality is much more complex – but there is little point in debating with those whose intellectual universe is populated by miniature demons.

Then there is the idea that Adorno is a bleak pessimist. Although it is not the truth, this at least has a basis in reality, in the aesthetics of Adorno's philosophical presentation. For there is an Adorno who claims that 'to write poetry after Auschwitz is barbaric'. This is the aphoristic Adorno, the Adorno of rhetorical exaggeration, whose method of presentation is to frame questions within opposed extremes and then compress these into a lapidary paradox. 'The wrong life cannot be rightly lived'; 'the wholly enlightened earth is radiant with triumphant calamity'; 'what can oppose the decline of the west is not a resurrected culture, but the utopia that is silently contained in the image of its decline'. As one radical philosopher comments, this is an 'early-warning strategy', where 'Adorno...projects [himself] in to the final catastrophic outcome of the "administered society" of total manipulation and the end of subjectivity, in order to stimulate us to act against this in our present' (Žižek, 2008: 460). Adorno writes:

The supposition of a grand plan for better world, manifest in and uniting history, would be, considering the catastrophes that have happened and in light of the catastrophes that might yet happen, cynical...No universal history leads from the state of nature to humanitarianism, but there is one that runs from the slingshot to the megaton bomb. (Adorno, 1966: 312; Adorno, 1973: 320)

The black-and-white photograph of the wilting tulip bending mournfully to expire at the base of its glass vase, on the front cover of my 1973 translation of *Adorno's Negative Dialectics*, says it all. Here is a work of strange beauty that you can slit your wrists to. The first wave of commentators on Adorno, unable to grasp Adorno's early-warning strategy or analytically differentiate the aesthetic form from its conceptual content, reinforced this impression. According to Martin Jay, Adorno's work is located within a set of force fields that include 'mandarin cultural conservatism' and 'a deep current of pessimism', alongside 'Romantic anti-capitalism' and a 'refusal to spell out the utopian alternative' (Jay, 1984: 18–20). Until recently, *Negative Dialectics* has been received solely as a 'bleak expression' of Adorno's 'melancholy science'. Meanwhile, his posthumous *Aesthetic Theory* has been seen as an intellectual strategy of 'aesthetic hibernation', a message in a bottle about art as messages in bottles.

Adorno is not a bleak pessimist. Indeed, there can be no question that for Adorno, the anticipation of reconciliation – permanent peace, a balance with nature, freedom from fear and hunger – is what makes life meaningful. This centres on aesthetics. Without doubt, Adorno stakes his hopes on modernist art: it speaks the truth about history, in defiance of power; it keeps alive the flame of a utopian desire for a better world. Adorno's reply to the accusation that modernism is a daemonic or decadent form of art is captured in his anecdote about Picasso in Paris during the Second World War:

(A)n officer of the Nazi occupation forces visited the painter in his studio and, pointing to *Guernica*, asked: 'Did you do that?' Picasso is said to have answered, 'No, you did'. Autonomous works of art, like this painting, firmly negate empirical reality, destroy the destroyer... (They) force the onlooker to try to decide whether (the artist) is announcing the culmination of disaster or salvation hidden within it. (Adorno, 2007a: 190, 195)

Picasso's *Guernica*, depicts the shattering torment of human beings and animal victims of the fascist bombing of civilians, by German warplanes, in the town of Guernica on 26 April 1937, during the Spanish Civil War.

The fragmented forms, painted in shades of grey, graphically express suffering, in what is perhaps the perfect statement of the protest character of modernist art. What is unusual about Adorno's reading of the painting is that he detects the inverse of suffering as well, for the very fact that the painter painted as he did, the fact of a cry of outrage, gives indignant voice to a deep upsurge of hope that things could be otherwise; even, that art, by denouncing such a world, could help to propagate hope for a better situation. *Guernica* could take no other form than the one that it does. To redeem the bombing back into beauty in the name of hope would be to betray the suffering that must be represented. Thus, the figures cannot be conventional representations of humans and animals in pain, for that would prematurely snatch redemption from catastrophe. It would do so by reintroducing the wholeness of the animate form, which is after all the original model for aesthetic beauty. But to let fragmentation entirely predominate would be to naturalise the disastrous condition of

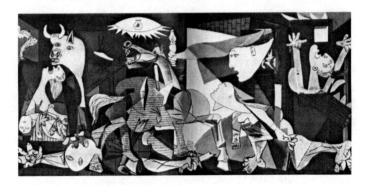

1. Picasso, *Guernica* (1937).

objectification that is to be denounced in the first place. The figure of the bull on the left-hand side reflects this tension, in the disjunction between an almost conventionally representational silhouette and the dislocation of its grimacing features. To describe this as 'cubist' is, in this instance, to say that both perspectives are simultaneously present.

The principle of hope

For Adorno, these two perspectives are critical 'negativity' and utopian 'reconciliation'. But already we face a key difficulty in interpreting his ideas. Compounding the impression made by his aesthetic strategies, Adorno's work is situated within a tradition of continental philosophy that he sometimes deploys without explanation. The effect created in the English-speaking world by terms like 'critical negativity' and 'melancholy science', was altogether different to Adorno's likely intentions. Once, confronted by a US journal editor's demand that he provide definitions, Adorno indignantly replied that this would be futile, for the essence of dialectical thinking is to regard even thought itself as thoroughly historical and therefore subject to change. Static definitions would falsify the movement of historical thinking by petrifying Adorno's mobile effort to register the fluidity of reality. An unforeseen by-product of this principled stance, however, has been not just the perception that Adorno's philosophy is bewilderingly difficult, but also some serious misunderstandings of his position as a whole.

From the perspective of dialectical philosophy, 'critical negativity' does not mean emotionally negative complaints about society, but rather refers to the contextualisation of moral and political ideals in historical forms of social life. In dialectical philosophy, as outlined by figures whose thought massively influences Adorno, such as G.W.F. Hegel (1770–1831) and Karl Marx (1818–83), 'the negative', or 'determinate negation', is the basis of all change and the key to progress in human freedom. Dialectically

speaking, to 'negate' is to intellectually grasp and then conceptually or manually transform the 'positivity' of the world of existing facts. Determinate negation happens when something positively existing, such as a set of established generic conventions in art, is contextualised and historicised, regarded not as an inert and isolated fact, but as the result of an ongoing process. What determinate negation reveals is that all social and historical processes are driven by contradictions, antagonistic relationships between dynamic oppositions. For instance, modern art in the broadest sense, Western European art since the Renaissance (1450–1650), has been characterised by the institution of art as a special department of activity exempt from social norms and simultaneously as a part of society subject to market forces. This antagonistic tension, between freedom for art from society and the social character of art, dynamises art history and culminates in modernism and postmodernism.

To 'critically negate' is to intervene in a contradictory process on the basis of an intellectual grasp of the forces of change operating beneath the surface of the world of facts. Picasso's modernist art, for instance, is often described as a deliberate transformation of the classical artworks of the Spanish painters El Greco and Velázquez. Modernist art is a negation of classical realism. For Adorno, to 'affirm' the world of positively existing facts is a *problem* – the *solution* is critical negativity. But in the English-speaking world's reception of Adorno, one often gets the feeling that the critics wish he would lighten up, perhaps because the positive (emotional) sense of (intellectual) negativity is missed outside the framework of dialectical philosophy.

Adorno's utopian vision of 'reconciliation' is where critical negativity leads. For Hegel, reconciliation means the historical resolution of social contradictions, through the achievement of a combination of political freedom with human happiness. Marx is in agreement, but he insists that this will only happen with the abolition of market relations and the construction of a communist

society. Marx also specifies that this will involve a new balance between human society and the natural environment, as human beings cease to regard nature (including the body) as a raw material to be commercially exploited. Marx's vision inspired Picasso and many other modernists to experiment radically with artistic forms, in search of liberating new modes of perception and an expanded range of feelings, consistent with this socially explosive desire for freedom and demand for happiness.

In the standard dialectical logic worked out by Hegel and Marx, the 'negation of the negation' into positive reconciliation follows with logical necessity and historical inevitability. Not so for Adorno. Adorno is highly sceptical of the 'march of progress', not least because it betrays suffering and disregards individuals while maintaining that it is 'all for the best in the long run'. The historical experience of socialist revolutions, which began with liberation but climaxed in totalitarianism, sufficiently illustrates the sorts of things that such views can license. For Adorno, dialectics must 'tarry with the negative', must risk remaining at the moment of critical negativity, hoping for a utopian reconciliation, but not daring to affirm its inevitability or to proclaim blueprints for the future society, lest it utterly betray the principle of hope that animates critical negativity in the first place. Thus, although Adorno's utopian concept of reconciliation most definitely includes the elimination of exploitation and a restored balance with nature, he refuses to provide details. Instead, what he does is to specify the minimal conditions that any meaningful reconciliation would have to satisfy: the elimination of torture and hunger; freedom from fear and persecution. It has to be said that in light of human history as a whole, this is a surprisingly demanding set of conditions. Adorno's reticence on the topic of reconciliation has often been related to his Jewish background, and the Judaic ban on worshipping idols, expressed in the Third Commandment, which forbids images of God. It is equally related to the

philosophical concept of a regulative Idea, an ideal standard that makes critical judgement possible, but which should never be mistaken for something in reality.

The Jewish and philosophical aspects of reconciliation are brought together in Ernst Bloch's Freud-influenced, Marxist work, *The Spirit of Utopia* (1918), which made a lasting impression on the young Adorno (Adorno, 1992: 211). The 'artistic joy' of the German modernist movement known as Expressionism, Bloch argues, springs from an anticipation of utopia that is social and psychological. Bloch proposes that Expressionism positions itself in opposition to reification and repression through its extreme stylisation and fantastic elements, because its aesthetic strategies of wish-fulfilment affirm those wishes which reality does not satisfy. Seeking to extend this artistic impulse into his philosophy, Bloch writes that thinking must be 'finally the revelation of that which has not yet come into existence'. In *Minima Moralia*, a prolonged meditation on philosophy after Auschwitz, Adorno agrees entirely that the principle of hope must never be abandoned:

The only philosophy which can be responsibly practised in the face of despair is the attempt to contemplate all things as they would present themselves from the standpoint of redemption. Knowledge has no light but that shed on the world by redemption: all else is reconstruction; mere technique. Perspectives must be fashioned that displace and estrange the world, reveal it to be, with its rifts and crevices, as indigent and distorted as it will appear one day in the messianic light. (Adorno, 2005: 247)

The utopia of youth

Detlev Claussen's authoritative biography, *Theodor W. Adorno: One Last Genius* (2008), provides the minimal coordinates for any full understanding of his work. Adorno was born in Frankfurt-am-Main under the birth name of Theodor Ludwig Wiesengrund, to Oskar Wiesengrund and Maria Calvelli-Adorno. His father had, characteristically for intellectually inclined,

middle-class German Jews of the era, assimilated by conversion to Christianity. His Catholic mother, a professional singer, shared the house with her unmarried sister, an accomplished pianist, and together they introduced the child to music. Adorno was extraordinarily gifted, both intellectually and musically, as reflected in a life's work divided exactly equally between an avant-garde philosophy and a highly original musicology.

Adorno's youth was shaped by the aftermath of the First World War (1914–18), when a wave of revolutions, inspired by the Russian Revolution (1917), swept Western Europe. Mass political movements erupted between 1918 and 1923, protesting against the carnage of the Western Front and demanding political change. These led to the end of the Kaiser's Germany and the establishment of the short-lived Weimar republic (1918–33), but they were only part of the radicalisation of Adorno's generation of intellectuals. For these were accompanied, on either side of the war, by the beginning of cultural modernism, and especially by Expressionism. The linked developments of political mobilisation animated by revolutionary enthusiasm, and the explosive emergence of artistic modernism, had a profound impact on the intelligentsia in Germany. In the English-speaking world, it is difficult to imagine the scale of these movements and the scope of modernism, for in England and America, radical parties and modernist journals remained on the fringes of social life. Not so in Germany. With Socialist and Communist parties whose combined membership numbered in excess of one hundred thousand, capable by 1930 of winning forty per cent of the vote, Germany came extremely close to socialist revolution. Expressionism, meanwhile, became so influential that it began to define mainstream cinema, literature and music, until the Nazis declared it 'degenerate art'. In the context of imaginative new ideas and a fresh vision of society, liberal and reformist Weimar Germany was a fertile environment for Adorno's combination of radical philosophy and experimental art.

Between 1918 and 1920, before the end of high school, Adorno was already captivated by the intellectual and political ferment of Weimar Germany. As soon as he went to university, he read the works of, and met, central figures of the Marxist intelligentsia. These included the Hegelian Marxist György Lukács, the utopian socialist Ernst Bloch, Max Horkheimer, the future director of the Frankfurt School, which Adorno was to join, and the highly unconventional Walter Benjamin. Most of them were openly hostile to the economic reductionism of orthodox Marxism and increasingly suspicious toward the alarming developments in the Soviet Union. Theirs was a 'cultural Marxism', which held that artistic experimentation and socialist revolution were all about freedom, and belonged together in the renovation of an entire way of life. This was not surprising, for the leading members of the cultural and artistic intelligentsia had also rallied to the cause of change. Dadaism and Surrealism proclaimed allegiance to the world revolution, Russian and Italian Futurism announced the advent of monumental convulsions, and, more modestly but no less emphatically, modernists across central Europe openly supported the reform-oriented parliamentary socialism of the Weimar Republic. The musical world was suddenly electrified by the rapid multiplication of leading composers who were breaking with the now sterile conventions of classical harmony and embracing atonal techniques – Béla Bartók, Igor Stravinsky, Anton Webern, Alban Berg, Arnold Schönberg, Paul Hindemith, Ernst Krenek and Kurt Eisler. Before the war, the bourgeois public had rioted at the opening of Stravinsky's *The Rite of Spring* (1913), and fist fights erupted during a performance of Schönberg's revised *Chamber Symphony No. 1 in E major Op. 9* (1907/1913). Now, in the altered atmosphere of cultural openness and political freedom, new thinking and new feelings, there were standing ovations lasting up to fifteen minutes and it was almost impossible to enter the crowded auditoriums.

Characteristically, when Adorno graduated from Frankfurt University with a PhD on Edmund Husserl's phenomenological philosophy in 1924, the first thing he did in 1925 was not to engage in philosophical debate, but to approach avant-garde composer Alban Berg. Adorno became one of Berg's students, which involved Adorno's participation in the avant-garde musical circles in Vienna around radical innovator Arnold Schönberg. Returning to Frankfurt further radicalised by an encounter with Sigmund Freud's new and revolutionary idea of psychoanalysis, Adorno ran into problems with his professorial dissertation on 'The Concept of the Unconscious in the Transcendental Theory of Mind' (1927). Increasingly interested in linking his interest in philosophy, art and psychoanalysis to the highly unorthodox Marxism of the Frankfurt School's Institute for Social Research led by Max Horkheimer, Adorno became a major contributor to the institute's journal in 1931. With incredible irony, his second professorial dissertation, *Kierkegaard: Construction of the Aesthetic* [1933] (1989), was published on the first day of Hitler's regime (Claussen, 2008: 85).

An opponent of fascism because of socialist convictions and Jewish background, Adorno fled into exile, initially to England, working at Oxford University (1934–37), and then to the United States, at Princeton University (1938–40). He married Margarethe Karplus, nicknamed Gretel, in London in 1937; she was to be his interlocutor, amanuensis and editor. Less fortunate was Adorno's friend, the equally celebrated intellectual Walter Benjamin, whose suicide when trapped at the French–Spanish border in 1940 struck Adorno deeply (Claussen, 2008: 127). Even in America, Adorno did not feel entirely safe; in 1942, acting perhaps on Horkheimer's advice, he hid the Jewish 'Wiesengrund' in the 'Theodor W.' and adopted his mother's Christian maiden name, Adorno (Claussen, 2008: 121). Hardly astonishingly, Adorno once defined liberation as emancipation from fear (Wiggershaus, 1994: 394). Perhaps surprisingly, this led Adorno to reaffirm the messianic anticipation

of utopian reconciliation, the principle of hope, as central to the ideas of dialectical theory and his critical aesthetics.

After the Second World War (1939–45), Adorno returned to Europe to participate in the democratic reconstruction of West Germany. As a public intellectual delivering open lectures and radio interviews, he was a leading figure in two important processes in the de-Nazification of the Federal Republic. The first was the politics of historical memory, challenging widespread amnesia about the Nazi past with the truth about the Hitler regime and its genocidal policies. This included confronting the intellectuals who had supported the regime, or had let their apathy become complicity. Martin Heidegger, whose philosophy, Adorno says, opened the path to fascist politics amongst German intellectuals, was the major figure critiqued. Adorno argues that existentialism is hostile to fully acknowledging social existence. It replaces historical thinking with grand metaphysical abstractions about Being, dressed up as a return to 'authenticity' and immediacy. But equally importantly, Adorno urgently sought to understand 'how Beethoven's people became Hitler's people', through a critique of European culture. This involved a dialectical sifting of cultural motifs. Adorno was especially concerned with the search for a 'new categorical imperative', or sense of moral duty: 'never again Auschwitz, nor anything similar' (Adorno, 1966: 356; Adorno, 1973: 365). For Adorno, a new morality would have to be supported by a renovated culture, one that would consolidate the best elements of the European Enlightenment and cultural modernity, through a critique of the socio-historical factors that led to its failure to prevent genocide. His posthumously published *Aesthetic Theory* is dedicated to that task.

The second was a challenge to the imposition of the methods of the natural sciences on sociology, in 'value-free' neo-positivism. This academic movement toward scientific management of social problems was deeply connected to the cultural conservatism of the Cold War. But Adorno argued that the problem with German

intellectual culture before the war was not that it lacked American methods, but that its valuation of freedom was completely inadequate. This was also true of apparently progressive figures who had, in the end, made their peace with Stalinist totalitarianism, basically on grounds that Stalin defeated Nazism at the Battle of Stalingrad (1943). Adorno bitterly rejected the 'resignation' of figures such as Berthold Brecht and György Lukács to Soviet orthodoxy, in the name of resistance to capitalism, regarding them as hypocritical anti-intellectuals. Nonetheless, his writing also became increasingly cryptic, as its political commitments were camouflaged under difficult expressions. For instance, Adorno maintains that 'from the perspective of concrete possibilities for utopia, dialectics is the ontology of the false state of affairs' (Adorno, 1966: 20; Adorno, 1973: 11). That is a rather indirect way of saying: dialectics diagnoses the potential for radical social transformation.

The student movements of the late 1960s at last broke with the anti-communist cultural consensus to launch a radical movement opposed to both Moscow and Washington. Yet by now, the radical youth were unsympathetic to the red professors. Adorno never abandoned the combination of critical negativity and utopian hope that characterised his youth. But its expression had moderated significantly, in light of historical experiences related to political authoritarianism. It was clear that what Adorno called the 'authoritarian personality' thrived within the bureaucratised capitalism of what he described as the modern, administered world. Sometimes, reading Adorno's late work, one gets the impression that the promise of happiness contained in experimental art is fated to indefinite postponement. At the same time, the Soviet Union and its gray clone, the Democratic Republic of East Germany, demonstrated to Adorno that Marx's collectivist vision of the future society was fatally flawed. Marx's dialectical philosophy was centred on a valorisation of collective labour and therefore, for Adorno, on

the exploitation of nature as raw materials and a certain disregard for the individual.

By the 1960s, Adorno is probably best described as the sort of Marxist who is an ethical individualist, rather than as any sort of traditional socialist. And Adorno, from beginning to end, rejected political violence as the means to utopian reconciliation, something that enraged the wing of the student movement which was eventually to support the terrorism of the Baader-Meinhof 'Red Army Faction' and the Italian Red Brigades. In Germany, the Students for a Democratic Society, protesting against the Vietnam War, radicalised after neo-fascist militants murdered two student leaders. In a climate of anti-intellectual militancy that valorised political activism and clashes with the police, Adorno was denounced as a reactionary. The Institute for Social Research was occupied by a militant splinter group seeking a confrontation with the authorities, and Adorno's lectures were regularly interrupted by students storming the podium. Before political developments in the direction of left wing militarism could clarify the arguments, Adorno died of a heart attack, after trekking in the Alps against doctors' orders.

Philosophical modernism

Adorno was a central figure in the unconventional Marxism that originated at the Institute for Social Research at Frankfurt University in the 1920s and 1930s. For a long time the only Marxist research institute in the West attached to a university department, it was relocated to New York in 1934 after Hitler came to power. Alongside Adorno, its personnel included important philosophers such as Max Horkheimer (1895–1973), Herbert Marcuse (1898–1979), Walter Benjamin (1892–1940) and Erich Fromm (1900–80). This group of anti-fascist and anti-Stalinist intellectuals developed a highly independent research programme whose aim was to critically update Marxism. Refusing to subscribe to any orthodoxy, they reminded readers of their journal that Marx called his ideas

'historical materialism', and not 'Marxism', and they sought to pose fundamental questions about contemporary capitalism from a non-dogmatic perspective. The major thinkers of the Frankfurt School were open to the insights not only of non-Marxist theories, but also interested in dialogue with deeply conservative thinkers, as well as new, radical developments in the arts. Furthermore, they considered Freud's discoveries about depth psychology essential to understanding the passionate subjectivity of the artistic rebels and political radicals of their era. Their aim was to integrate the results of specialised inquiries into political economy, culture and ideology, psychology and philosophy, into an open-ended and ongoing intellectual project. At the same time, they were deeply critical of the orthodox Marxism of the Stalinist parties, regarding historical materialism as a means to re-open ancient questions about the good life and meaningful human existence, rather than as assembly instructions for a prefabricated utopia. Members of the Frankfurt School prudently described their research program as 'Critical Theory' partly as a euphemism for historical materialism that they hoped would deflect hostile attention, and partly to signify their distance from orthodox forms of Marxism. What differentiates Adorno's Critical Theory from all of the others, with the possible exception of Walter Benjamin, is his focus on aesthetics, including the aesthetics of his philosophical presentation. It is both accurate and helpful to say that Adorno 'composed' his philosophy.

Indeed, Adorno felt permanently divided between becoming a philosophy professor and developing as a professional composer. He is sometimes pictured reading sheet music like others read newspapers, which reflects reality rather than pretence, and he was a gifted pianist, whose idea of understanding a difficult sonata was not to put a record on, but to sit down and play it through once or twice. He insisted that his philosophical works exhibited artistic 'construction', modelled on the procedures of atonal music, composing only a philosophy in fragments, while

maintaining that artworks lay claims to philosophical truth. His work has rightly been described as an 'atonal philosophy' (Buck-Morss, 1977: 36), and this in fact provides the key to interpreting Adorno's aesthetic strategies for presenting philosophical arguments. According to musicological definitions, 'atonality' is a:

system of composition in which all 12 notes within the octave (7 white and 5 black notes of the piano scale) are treated as 'equal,' in an ordered relationship where no group of notes predominates as in major/minor key system... (I)t is associated with Schönberg, whose 'method of composing with 12 notes which are related only to one another' was developed gradually between 1920–5... In the Schönberg method, all pitches are related to a fixed order of the 12 chromatic notes, this order providing the work's basic shape. The fixed order is called a note-row (or series or set). No note is repeated within a row, which therefore comprises 12 different notes and no other. The note-row is not a theme but a source from which the composition is made. It can be transposed to begin on any of the 12 pitches, and it may appear in retrograde, inversion, and retrograde-inversion. Since each of these transformations may also be transposed, each note-row can have 48 related pitch successions. Schönberg's foremost contemporary disciples were Berg and Webern. (Kennedy and Kennedy, 2007)

This composition using atonal sequences, or 'motifs', based on groups of twelve notes and their systematic transformations, does two things. It shatters the easy listening of the harmonic intervals that are the basis for classical music and modern pop, breaking with the formulaic conventions that make most sonata and song forms familiar and recognisable. It forces the audience to develop the attentive hearing within which this music can be enjoyed, by driving perception down to the micrological level of the motif and the transition. (Modernist art and literature do the same thing: they break with realist depiction and narration, forcing perception to concentrate on the fragment of representation and on the individual sentence.) Perception must ascend to a fresh understanding of the whole, considered as the tension and

interplay between elements, rather than as a pre-given schema that subordinates details in the work to a grand conception.

Adorno does the same thing with philosophy. He located himself within the most advanced current of modern philosophy in the 1920s, known as phenomenology, which began from the micrological details of concrete experience. Just as modernism broke with nineteenth-century realism, phenomenology aimed to break from nineteenth-century neo-Kantian idealism. Its aim was to reconstruct rationality without reference to the global abstractions of idealist philosophy, thereby refreshing thinking by abandoning reified conceptions. But soon an irrationalist current within phenomenology, known as existentialism, arose, which proposed to cleave to experience *against* reason. Immediate experience was supposedly 'authentic', even natural and pure, as against historical and social thinking about that experience. In opposition to what he calls the 'jargon of authenticity', Adorno seeks to develop the phenomenological insight without surrendering to the lure of the immediate, and abandoning the historical and social contextualisation of ideas.

Adorno's approach begins from an experience and shows how an abstraction emerges from it. But then he rotates the experience into a new perspective and demonstrates how exactly the opposite idea now emerges. Technically, these mutually exclusive ideas springing from the same ground are 'antinomies', and Adorno uses this antinomic construction to show something about the experience itself. For, Adorno characteristically argues, the antinomies of idealist philosophy are not intellectual mistakes or logical errors, but are rooted in the historical and social nature of the experiences they are intended to clarify. He then often introduces further antinomic pairs, to throw additional light on the experience, in a process of construction not unlike Schönberg's use of inversions and retrograde inversions to illuminate a note sequence. As Susan Buck-Morss proposes, 'Schönberg's revolution in music provided the inspiration for Adorno's efforts in philosophy... For just as

Schönberg had overthrown tonality, the decaying form of bourgeois music, so Adorno…attempted to overthrow idealism, the decaying form of bourgeois philosophy' (Buck-Morss, 1977: 36).

Accordingly, what Adorno characteristically does is to zero in on an experience and reconstruct the historical and social context of the ideas that make this experience accessible, without himself relying, as foundations, on reified totalisations such as History, Freedom and the Subject. Why? James Joyce demonstrates that realist literature is only one form of writing. Picasso shows how naturalistic depiction is only one of the possible artistic conventions. Schönberg proves that harmonic intervals are only an arbitrary way of organising the twelve chromatic notes. Likewise, Adorno aims to exhibit history, freedom and the subject emerging as abstractions from a historical and social process of thinking about experience, one that might be otherwise than it is today. To do this, Adorno thinks in what he calls 'constellations', groupings of ideas that make connections between aspects of experience without coercing these conceptually into a formal system. These constellated ideas are themselves presented through a highly aestheticised prose style that is designed to resist too-easy reduction in line with the reader's preconceptions. The stark oppositions and startling aphorisms of Adorno's modernist philosophical style reflect an angular mode of thinking, one that seeks to remain true to the fragment of experience. Adorno highlights the particular and the non-identical, the moment in experience that refuses the idealist synthesis of abstract universals. His sentences are strongly sculpted and densely textured, arresting attention with their striking reversals and contrasts between dark and light, critical negation and utopian hope. They develop into paragraphs and then essays through 'parataxis', a mode of expression that suppresses conventional syntactical connections and instead uses juxtaposition to make links, maintaining affinities between ideas without these collapsing into causal relations. (An example of

parataxis is the shift from 'the dog was frightened because of the thunder' to 'a clap of thunder; the dog quaking'.) For Adorno, the essay is the best form for his philosophy of the non-identical and the constellation, because essays are fragments that explore an aspect of their subject-matter, but do not belong in a philosophical system (Adorno, 2000).

Adorno Reframed

To describe Schönberg's music as bleak would be meaningless. Yet Adorno, as we have seen, is regularly dismissed on grounds that conflate his method of presentation, through rhetorical exaggerations and ideas in extreme tension, with Adorno's underlying substantive convictions. This book reframes Adorno, by presenting his thought as situated in the same context that produced Expressionism in the interwar years and Abstract Expressionism in the postwar era. Adorno's philosophy and musicology respond to the same socio-historical events as Expressionism, in ways that self-consciously and deliberately echo artistic procedures. To remain true to the 'utopia of youth' is to maintain the connection between avant-garde movements and radical politics, both of which are, for Adorno, marked by a focus on the uprising of passionate subjectivity against reified objectivity.

As Douglas Kellner points out, in his and Stephen Bronner's superb collection of re-interpretations of Expressionism, the movement is wrongly thought of in terms of 'irrational pathos, mystical vision and formal innovations' (Kellner, 1983: 3). Expressionism was 'an avant-garde artistic movement which responded rebelliously to the development of bourgeois society in the era of industrial capitalism' (Kellner, 1983: 3). Expressionism included major figures in painting (Kandinsky, Klee), literature (Kafka, Döblin, Wedekind, Benn), music (Berg, Schönberg, Webern, Stravinsky) and film (Wiene, Lang), all of whom explored the human implications of the social developments of the 1920s.

Germany's belated modernisation at the turn of the century led to the rapid imposition of urbanisation, commercialisation and industrialisation on the population. Fresh from the horrors of the First World War – a war fought between kings and emperors on behalf of bankers and industrialists – the Expressionists 'violently opposed the bourgeois ideologies of science and progress' (Kellner, 1983: 27). They grasped the connection between a technological society, scientific-technical reason and that dehumanisation of everyday life which culminated in mechanised battlefields. They also made the connection between these conditions in factories and offices, and the reduction of all human relationships to the cash nexus that was brought on by capitalist economics and consumer society.

Through the extreme stylisation of Expressionist aesthetics, the artists in revolt sought to apply shock therapy to a bewildered population, aiming to defamiliarise individuals from their habitual routines so that they could confront the dehumanisation that social normality really involved. They depicted a gothic, distorted world, dominated by what Marx called 'the icy waters of egotistical calculation', the principle of cold calculation of cash value that considers even human beings as things to be instrumentally manipulated. Against objective knowledge and capitalist industrialisation, the Expressionists championed 'subjective expression and individual vision', asserting the importance of passionate subjectivity and its right to cultural and political rebellion (Kellner, 1983: 27).

Fritz Lang's classic example of Expressionist cinema, *Metropolis* (1927), for instance, is science fiction set in a dystopian future, where the world is divided between workers and planners, supporting an ultra-rich caste of the luxurious elite, who are protected by the machinations of a mad scientist and his humanoid robot. Throughout the convoluted twists of the narrative, having to do with love and revenge against a backdrop of workers' revolt and elite callousness, the basic idea is of the

breakthrough of human passions despite a world of hostile objects (especially the android). Drawing on biblical and mythological themes to do with the worship of money and power, the film's astonishing aesthetics conjure an urban landscape of corporate and bureaucratic architectural triumphalism (not unlike today's cities, as a matter of fact). The starkness of the lighting and the film's angular set reinforces its substantive contrast between reified power and defiant subjectivity.

Robert Wiene's film, *The Cabinet of Dr Caligari* (1920), emphasises the distortion of the objective world by the subjective dimension even more strongly. In the gothic sets and post-Romantic aesthetics of the world of another mad scientist, the frightening Doctor Caligari, the supposed neutrality of reified objectivity is decoded as a mask for the subjective desire to manipulate and dominate.

The angular 'wrongness' of the cinematic set reflects the denaturalisation of domination. The everyday, normal world of reified objectivity and instrumental manipulation, the result of scientific neutrality, supposedly expresses no subjectivity whatsoever. Yet it appears as startlingly distorted once the subjectivity that really animates it is expressed in its objective forms. Wiene's set makes it appear as if all of a sudden the buildings of the real world announced visibly that they were the result of accepting domination as natural. The stylised characterisation of gesture and interaction of the actors, together with their disordered appearance, reflect human subjectivity *in extremis*, confronted by apparently overwhelming forces that seek to externally direct individuals and negate human freedom.

Now, the argument of this book is that we should read Adorno's philosophy and musicology in the context of Expressionist cinema, literature, painting and music. That Adorno's aesthetic strategies for the presentation of philosophical ideas reflect a rebellion of subjectivity against an oppressive objectivity, does not mean that his work is 'conceptual poetry'. Adorno's work is rigorous

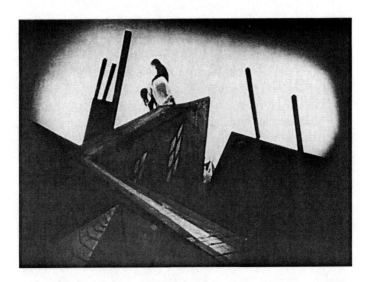

2. Still from *The Cabinet of Dr Caligari* (1920).

philosophy that is persistently aware of how the stylistics of presentation affect whether something is merely consumed, or whether the resistance of the sentences to too-easy comprehension promotes thoughtful reflection.

- Chapter one introduces Adorno's social and cultural theory through an examination of his contribution to the Frankfurt School. It locates the core ideas of Frankfurt School Marxism against their intellectual background and contextualises them with reference to parallel developments in the arts, especially around Expressionism.
- Chapter two clarifies the connection between art and society by exploring Adorno's reconstruction of art history in music. It contextualises this in relation to painting, demonstrating how Adorno's ideas can be used to understand modernist movements in the visual arts.

- Chapter three examines Adorno's aesthetic theory against the background of his art history and illustrates this in the context of Neo-Expressionism. It clarifies crucial relations between material and technique, form and content, and significance and impact, before explaining Adorno's concept of 'artistic truth'.
- Chapter four turns to the present. It investigates the continued relevance of Adorno in the context of postmodern culture, before looking at feminism's reception of his philosophy. The fertility of Adorno's philosophy for contemporary thinking is not restricted to his aesthetics, but embraces significant questions about the nature of modernity and rational justifications for hope.

We must not imagine that locating Adorno in the context of interwar Expressionism and postwar Neo-Expressionism fatally dates his thinking. Adorno is right up-to-date in the context of postmodernism. In fact, in his critique of 'Adorno as the Devil', contemporary philosopher Jean-François Lyotard regards Adorno as his most serious opponent within the postmodern condition (Lyotard, 1974: 136). Adorno, like Lyotard, intends to 'wage war on totality', to reject the principle of systematic rationalisation in the interests of a defence of the individual as unique – that is, in the name of difference. But as far as Lyotard is concerned, Adorno's thinking must be rejected by postmodern philosophy, because the principle of hope is too central to Adorno's position.

Lyotard's interpretation is subtle: he returns to the image of Adorno in Mann's *Doctor Faustus* to propose that Adorno is the Devil, because he is the advocate of an inverted – that is, a negative – theology. What this means is that Adorno, for Lyotard, has failed to fully reject Marxism's secularisation of the religious hope for a better world. For Adorno, as Lyotard summarises, 'the reconciliation of the subject and the object has been perverted [by modern society] into a satanic parody, into a liquidation of the subject into the objective order' (Lyotard, 1974: 132). For Lyotard,

this critique depends on Adorno's possession of a vision of a better world. But Adorno is no longer a Marxist, which means that the threat of the liquidation of individuality is not certain to be 'dialectically' reversed into a new vision of human flourishing by means of communist revolution. Yet without the perspective of a social alternative, one that can only be glimpsed in the present and which would be betrayed by its articulation as a blueprint, Adorno lacks a normative standard for his penetrating criticisms. Therefore, Adorno retains the Marxist diagnosis, but rejects the Marxist cure.

So for Lyotard, the problem with Adorno is that, despite his reservations about Marx, there remains the ideal of a social alternative, a utopian reconciliation between humanity and nature, and amongst human beings, as the framework for the critique of contemporary culture. Adorno has a theology. But Adorno thinks that the only way to present the vision of reconciliation is through the representation of the broken promise of happiness and the critique of modernity's desolation of human hopes. Adorno has a negative theology. Indeed, for Adorno, Marxist faith in historical progress is misplaced, because the only cumulative narrative in the modern world is the one about increasing domination. This is Marxism 'upside-down'. Adorno has an inverted, negative theology. Therefore, Adorno is not God, but the Devil.

Adorno, Lyotard alleges, depends upon his 'negative theology' of 'utopian reconciliation', because this directs Adorno's criticism of the totalitarian potentials of the administered society. Lyotard understands very clearly that Adorno is not a pessimist. Hope is Adorno's problem. Were it not for his utopianism, Adorno would line up with Lyotard, especially on aesthetic questions, Lyotard thinks. Adorno is completely relevant to the postmodern condition, in every respect except for his refusal to 'play along' (*nicht mitmachen* – Adorno's favourite expression) with contemporary capitalism. Astonishingly, Lyotard proposes that we should reject Adorno and accomplish the shift from criticism into affirmation,

from dissent with society into acceptance of existing arrangements. We really should abandon utopian expectations, Lyotard proposes. For Lyotard, with intense cynicism, contemporary culture is all about 'just gaming', under conditions where the historical narrative of emancipation is exhausted. 'We have the advantage over Adorno,' Lyotard remarks, 'of living in a capitalism that is more energetic, more cynical, less tragic,' a system where 'the tragic gives way to the parodic' (Lyotard, 1974: 128). But in truth, the difference between the tragic and the parodic probably depends on whether you take the side of the victims, or not.

This is a book about Adorno's aesthetics, not about the inhumanity of capitalism. But Lyotard's perspective is a useful corrective to popular perceptions of Adorno as grimly depressing. As we proceed, the limitations of Lyotard's position on Adorno will become obvious. Nonetheless, the image of Adorno as the Devil is valuable, because it preserves the idea that there is something thorny and persistent about his questions, and that in the present state of things, it is really Adorno who has to be answered, more than anyone else.

Chapter 1

Negative dialectics

Probably the most startling thing about modernism today is that it is no longer shocking. Domesticated into coffee-table art books, it has become an accepted component in the unfolding history of Western art. Most respectable middle-class households have somewhere or other a reproduction of a Picasso or a Kandinsky. Generally reduced to its formal component, the modernist aesthetic becomes a comforting experiment with collage techniques and multiple perspectives. Standard academic introductions to modernism propose that it is a subjective reflection of the experience of the industrialised city, reducing abstraction to the normal perception of a new environment. It is now almost impossible to imagine how any rational person could have criticised these superannuated circus animals, or taken offence at their tired antics. In other words, we have entirely lost touch with the vitality – and the virulence – of modernism.

Critics who try to rediscover the original bite of modernist art are forced into desperate measures, in order to estrange our reception of modernism and make it new again. In *Fables of Aggression: The Modernist as Fascist* [1979], Fredric Jameson, for instance, turns to the now forgotten literary Expressionism of Wyndham Lewis. 'It has been my experience,' writes Jameson, 'that new readers can be electrified by exposure' to Lewis' books, 'in which, as in few others, the sentence is reinvented with all the force of origins, as sculptural gesture and fiat in the void' (Jameson, 1979: 2). True enough, but he might have mentioned that

to get there, they need to put up with Lewis' racism, which is generously larded with misogyny. Interestingly, though, what Jameson does add is that 'such reinvention demands new reading habits, for which we are less and less prepared' (Jameson, 1979: 2).

To rediscover the radical energy of modernism, we need to make it strange. How then, to recover the freshness and sting of both Adorno's philosophical modernism and the Expressionist art that he defended? The reader will be relieved to learn that there is an alternative to enduring an aesthetic presentation of the politics of hate, on the lines of Wyndham Lewis, as a means to estrange ourselves from a routinised reception of the modernism that Adorno advocated. That alternative is to prepare ourselves to read more attentively, by seriously considering the possibility that modernism is a major mistake. Of course, our instant response is something like, 'who on earth would reject Joyce and Picasso?' But as a matter of fact, Adorno in the 1930s and 1940s confronted a progressive intellectual perspective of considerable depth and sophistication that argued just this.

This chapter argues for a new perspective on Adorno's social theory, as a preparation for viewing his aesthetics in a fresh light. To achieve this, it begins from the critique of modernism against which Adorno had to defend it, that of the Hegelian Marxism of György Lukács. Only once it ceases to be obvious to us that modernism is automatically legitimate will it be possible to see what it is, exactly, that Adorno is advocating, and where he is coming from in doing so. For the risk is not actually *reading* Adorno at all – any more than we have seen, heard or read modernism. We have to avoid a selective and superficial examination of his writings guided by our preconceptions, ignoring anything that doesn't seem to fit. Adorno's version of Critical Theory deserves better.

Commodity reification and realist art

In the 1920s, Lukács was seeking to recover a version of Marx's historical materialism that could pose a philosophically significant challenge to the dehumanisation of individuals under capitalism. Before panicked representatives of Stalinist orthodoxy silenced him, Lukács managed to rediscover the humanist critical theory of the young Marx. According to Marx's youthful writings, capitalism generated what he called 'alienation', which is not a psychological feeling but an existential condition. Under conditions of capitalist alienation, human beings confront the social world, the natural environment, other people and even themselves, as raw material to be instrumentally manipulated (Marx, 1964: 77–79).

According to Marx, alienation happens because a market society depends upon what Marx called 'real abstraction', the way in which everything becomes measured in money. Money is an abstract representation of the labour time embodied in commodities, useful items produced for profit and sold on the market. Money functions as a 'general equivalent' or medium of circulation in capitalism, enabling qualitatively unlike things (different objects) to exchange in the medium of quantitative likeness (monetary amounts). Describing the monetarisation of human relationships as 'commodity fetishism', Marx criticised how, through the abstraction of money, 'definite social relations between men and women assume, in their eyes, the fantastic form of a [monetary] relation between things' (Marx, 1963: 72). This is part of Marx's more general criticism of how, under capitalism, formal economic equality conceals substantive economic inequality, and the political liberty of the modern individual turns out to involve their isolation from society. Under capitalism, Marx wrote, there is 'no other nexus between human beings than naked self-interest, than callous cash payment'. Consequently, all interpersonal relations are 'drowned in the icy water of egotistical calculation' (Marx and Engels, 1986: 38).

For Lukács, the young Marx's critique of capitalist alienation and commodity fetishism represented a potentially fertile critical perspective from which to understand conditions in the 1920s. In his extraordinarily influential work *History and Class Consciousness* (1923), Lukács combines Marx's critique of commodity fetishism with an analysis of modern bureaucracy taken from non-Marxist sociologist Max Weber, to criticise twentieth-century capitalism's dehumanisation of society as a whole. Lukács' major insight was to connect the treatment of persons as things, which happens because of capitalist alienation and the fetishisation of money typical of market societies, with an apparently unrelated phenomenon, the development of rational management techniques. By the 1920s, the modern nation state had become a vast bureaucracy specialising in the technical management of economic growth and social problems, where rational planning and irrational exploitation went hand-in-hand. In factories and offices, the scientific management techniques of Fredrick Taylor and the mechanised production line of Henry Ford had overnight transformed work into a process where every minute mattered. New entertainment industries mushroomed at the same time that department stores with consumer products appeared. These were highly commercialised and organised on industrial lines, promoting culture and leisure for the masses in ways calculated to provide an escape from work and turn a tidy profit at the same time. The 1920s poster by radical Dada artist John Heartfield expresses the mood of times perfectly: 'rationalisation is on the march', it says; and, it shows a humanoid made of machine parts with a clock for a head, running desperately to keep up with the new pace of sped-up work and commercialised leisure.

What commercialisation and bureaucracy have in common is the reduction of reason to a faculty for performing calculations. Rationality as the ability to reflect on the substantive goals of human action and the forms of life conducive to human flourishing

is abandoned for formal operations. Lukács proposes that this signifies that the commodity has become the 'central structural principle' of the modern world (Lukács, 1971: 86), structuring both society and the psyche, through its mechanisms of abstract equivalence and quantitative calculation. The result is the invasion of the logic of the commodity into the fields of reason, culture and the psyche, in what Lukács ominously describes as 'reification' (i.e., petrifaction). The reification of individuals has resulted in the modern phenomenon of the 'individual without qualities', the anonymous bureaucrat or amoral entrepreneur, motivated only by formal procedures and instrumental calculations.

For the sort of reified thinking involved in modern management, Lukács argues, the ultimate intellectual ideal is the reduction of social questions to mathematical formulae, in order to manipulate individuals and manage processes. Lukács argues that these formal systems are actually highly fragmented. Specialised knowledge based on formal rationality breaks apart into disciplinary silos, with the effect of a compartmentalisation of society into a host of unrelated domains of activity, whose only apparent connection is through market mechanisms. What this obscures is the central truth of human existence, that historical societies are generated through human actions – through labour practice – and not through the anonymous and impersonal mechanisms that mediate between human agents. Labour, Lukács proposes, is hidden by the fragmentation of the cultural field, for reification involves the loss of every image of the social whole. This is because the experience of oneself and the world as things rules out any integrated standpoint from which to grasp the relation between society and individual as generated through historically conditioned human action. Consequently, artistic representations tend to reflect a kaleidoscope of fragments and philosophical systems tend to be characterised by basic divisions rather than fundamental unity. Bourgeois art and philosophy remain confined within 'antinomies', or mutually exclusive

conclusions from a single premise, because these arise from the limitations of capitalism as a form of life.

The solution, Lukács proposes, is intellectual and social revolution. The intellectual revolution is carried by the category of totality, as the antidote to reification, for *'the category of the totality is the bearer of the principle of revolution in science'* (Lukács, 1971: 27). By totality, Lukács means a conceptual systematisation of social reality into a unified theoretical whole, and it is best illustrated by Lukács' ideas about realist literary works. According to Lukács, literary realism, as practised by, for instance, Thomas Mann, makes it possible for readers to grasp capitalist society as a historical whole (Lukács, 1964). The realist novelist selects characters that are socially typical for their class position and then endows them with a plausible psychology, in order to generate a believable, richly detailed socio-historical world, populated by realistic individuals. In literary realism, a wealth of social relations and historical connections is established, centred on the experiences of the characters as they develop within the ideological limitations of their world. Narrative is therefore the process by which typical, but plausible, characters, come to know their world through actions within it, thereby simultaneously transforming the world and grasping it cognitively.

The significance of this is that the realist artist must represent the experience of everyday life by portraying it as the product of historical social relations, in a vast network of human actions. Such a perspective implies that the fragmentation of culture and the confusing multiplication of different perspectives in modern life are superficial – the result of certain kinds of actions and values, not just automatic features of the human condition. Realist art, therefore, is potentially revolutionary, because it lets men and women understand that the extreme opposition between the individual and society under capitalism is not natural and inevitable, but the product of historical circumstances. Although

Lukács' arguments concern realist literature, they apply equally well to realist painting, for the representation of a historical world through the plight of believable individuals is also present in, for instance, Giuseppe Pellizza da Volpedo's celebrated *Il quarto stato* ('the fourth estate').

The concept of a fourth estate refers to a social group not officially recognised. The painting therefore represents the emergence into political life of Marx's 'class with radical chains', the working class, denied many civil rights in Italy until after the First World War. Sometimes erroneously grouped with the neo-Impressionists, da Volpedo in actuality recruited the Impressionists' technique of painting in small dots and use of colour theory into the service of a more scientific representation of reality. The emphasis on the subjective act of perception of the Impressionists is replaced by the lively subjectivity of the people depicted, who are represented within the framework of classical linear perspective and the accurate portrayal of the human form. Their advancing line, in which they appear to emerge from darkness while narrating their life histories to one another, as if in making themselves heard by society they also make themselves

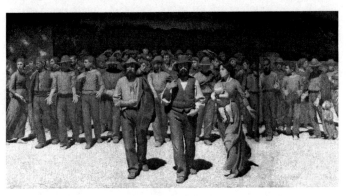

3. Giuseppe Pellizza da Volpedo,
Il quarto stato (1901).

known to one another for the first time, connotes the march of progress and reason. At the same time, the strikers have something ominously sacrificial about them, for their open hands show them to be unarmed to the perspective from which the painting is painted, presumably the police lines. A woman, perhaps the wife of the central figure, remonstrates with the determined leader, underlining her appeal for caution with the vulnerable child carried on her arm. Yet the gaunt faces of the strikers and the challenging look the front rank throws out to the observer speaks of a defiant human dignity, in spite of the poverty of their social, political and military means.

Thinking of just such works, Lukács insists that the realist artwork, 'by its very nature, offers a truer, more complete, more vivid and more dynamic reflection of reality than the recipient otherwise possesses' (Lukács, 1970: 36). The reception of realist artworks brings the reader's 'whole soul into motion' (Lukács, 1963: 767). Through its presentation of historical life as a dynamic totality, realist art has the potential to transform the 'whole human being' of everyday life into the 'person as a whole' of the aesthetic experience (Lukács, 1963: 767). Realist artworks therefore act to catalyse an intellectual grasp of the socio-historical totality, together with ethical regeneration, renovated perceptions and deepened feelings. Their cathartic impact confronts the individual with an emotional recognition of the 'unity and totality of all-rounded human being' that conveys the fundamental aesthetic imperative: 'you must change your life!' (Lukács, 1963: 786).

The Expressionism debate

Against this theoretical background, Lukács' intervention into the 'Expressionism debate' amongst the Western European intelligentsia sent a shock through progressive ranks. The assumption of theorists like Bloch was that modernism was progressive because its distorted forms and rejection of artistic coherence truly reflected modern reality. Expressionism in

particular shattered outdated artistic traditions, displaying the industrialised world in all its ugliness, while liberating subjectivity from the constraints of realist conventions. In both Expressionism and Surrealism, there is what Lukács calls, following Bloch, a 'vivid evocation of the disintegration, discontinuities and ruptures... typical of people living in the [present] age'. Further, Bloch writes, 'in its original form, Expressionism meant the shattering of images, it meant breaking up the surface from [a] subjective, perspective, one which wrenched things apart and dislocated them' (Lukács, 2007: 36–37). According to Bloch, then, Expressionism reflects the experience of breakdown that belongs to the crisis of capitalism, and anybody who criticises modernism is 'confusing experiments in demolition with a condition of decadence' (Bloch, 2007: 22).

The brilliance of Lukács' reply is that he entirely accepts this description of modernism, but completely rejects Bloch's evaluation of its significance and legitimacy. Modernism is a true report of how it feels to live in the modern world, from the subjective perspective of the isolated individual, who is overwhelmed and threatened by an unintelligible and reified society.

The modern literary schools of the imperialist era, from Naturalism to Surrealism, which have followed one another in swift succession, all have one feature in common. They take reality exactly as it manifests itself to the writer and the characters he creates. The form of this immediate manifestation changes as society changes... It is these changes that bring about the swift succession of literary schools... (all of whom) develop their own artistic style as a spontaneous expression of their immediate experience. (Lukács, 2007: 36–37)

But for this very reason, he maintains, modernism remains abstract, one-dimensional and superficial, for 'when the surface of life is only experienced immediately, it remains opaque, fragmentary, chaotic and uncomprehended' (Lukács, 2007: 39). For both Bloch and Lukács, the representation of this swirling confusion from the subjective perspective is expressed perfectly

in the juxtaposition of unrelated elements in the technique of collage. (It must be noted that in the debates of the interwar era, no distinction is made between the literary technique of pastiche, the painterly technique of collage and the cinematic technique of montage, just as no distinction is made between modernism as whole, and Expressionism, Cubism and Surrealism.) Collage, Bloch proposes, is 'an account of the chaos of reality as actually experienced, with all its caesuras and dismantled structures of the past' (Bloch, 2007: 24). Indeed, Lukács comments. Quite right. 'Bloch's mistake lies merely in the fact that he identifies this state of mind directly and unreservedly with reality itself' (Lukács, 2007: 34).

It is crucial to keep in view that the stake in this debate is not solely whether modernism is good art, according to exclusively formal aesthetic criteria. The underlying question is whether modernism is *progressive*; that is, whether its reinvention of perception and representation of feelings make a contribution to democratic values and human emancipation. The point Lukács is making here is that it is impossible to be a democratic progressive and hold that reality is a chaos of fragments. If an individual stands for social justice, democratic equality, human solidarity and the importance of truth in claims to knowledge, then that individual commits themselves to two things. They appeal to shared values established through rational argument, and they relate this to a reality that is fundamentally intelligible and accessible to human intervention.

Lukács' position is that, unlike modernism, realism has an emancipatory potential irrespective of the author's worldview. This is because it belongs to the concept of realist art, in that it reconstructs the historical and social world as a totality of human actions. By contrast, he argues, the concept of modernist art is concentrated in the technique of collage, which represents the world from a subjective perspective as a constellation of unrelated elements. His point, then, is that this expression of

disintegration is perfectly compatible with both fascism and an individual exclamation of distress and dismay, but not with an intellectual and social alternative to political authoritarianism and cultural elitism. Lukács argues that 'if Thomas Mann had contented himself with the direct photographic record of the ideas and scraps of experience of his characters, and with using them to construct a montage, he might easily have produced a portrait as "artistically progressive" as Joyce' (Lukács, 2007: 35). But what Mann, as a realist, *must do*, is to confront his limited characters' subjective perceptions with the totality of a historical world, within which their experiences appear *as limited*, and as limited precisely by that historical world.

The large-scale, enduring resonance of the great works of realism is due to their accessibility, to the infinite multiplicity of doors through which entry is possible. The wealth of the characterisation, the profound and accurate grasp of constant and typical manifestations of human life is what produces the progressive reverberation of these works. The process of appropriation enables readers to clarify their own experiences and understanding of life and to broaden their own horizons... Through the mediation of realist literature, the soul of the masses is made receptive to an understanding of the great, progressive and democratic epoch of human history. (Lukács, 2007: 56)

For Lukács, realist works are deep (not superficial) and complex (not one-dimensional), yet popularly accessible, rather than deliberately difficult works reserved for cultural specialists.

Adorno's social theory

Perhaps it is now possible to see that Adorno had to make an *argument* – as opposed to stating some self-evident truths – in defence of modernism. Adorno's argument with Lukács, and by extension, with Hegel and Marx, is all the more interesting because in fact there are a lot of areas of agreement. Not only did both Adorno and Lukács use dialectical theory, but Adorno and

his co-thinkers in the Frankfurt School accepted that the concept of reification was extraordinarily fertile. Nonetheless, there are three crucial differences between Adorno's Critical Theory and Lukács' Hegelian Marxism that support their major difference on the question of modernism.

The first major difference concerns the status of the totality. For Lukács, the aesthetic totality of the realist artwork must create a unified world for its typical characters. So too, the intellectual totality of Marxist theory must include knowledge of the entirety of reality in a single framework. Marxism is an all-embracing theoretical system not unlike Hegel's ideal of 'absolute knowledge'. It is so because it is the social theory of the proletariat – that is, the working class as revolutionary agent – which Lukács considers to be the author of reality, nothing less than the metaphysically grandiose 'identical subject-object of history' (Lukács, 1971: 206).

By contrast, for Adorno's Critical Theory, an intellectual grasp of society must be the result of an ongoing effort to integrate different sorts of knowledge into a multi-disciplinary research program. In a series of articles for the Institute's journal that culminated in 'Traditional and Critical Theory' (1937), Adorno's co-thinker Max Horkheimer presented the idea that historical materialism is a dialectical method of analysis, not a grand theory of everything (Horkheimer, 1982: 188–243). Critical Theory uses the procedure of determinate negation to specify the social connections between isolated abstractions and locate them in their context. Instead of a 'proletarian science' totally opposed to traditional knowledge, Critical Theory consists of an integration of the most recent discoveries into an ongoing synthesis. Implicitly drawing upon the critique of reification, Horkheimer argues that capitalist society appears to bourgeois consciousness as a 'sum total of facts' submitted to 'the classificatory thinking of each individual', in the interests of effective adaptation to social reality (Horkheimer, 1982: 199). The disciplinary silos of traditional sociology and bourgeois

philosophy tend to divide social reality into separate compartments. Taking the closed systems of mathematical formalisations of knowledge, such as economics, as their model, mainstream sociology eliminates substantive questions about whether social reality promotes the good life (Horkheimer, 1982: 199–205). A dialectical methodology breaks down the isolated silos of the bourgeois academic disciplines by grasping the social and historical interconnections between economics, sociology, political science, cultural criticism, psychology and philosophy. At the same time, Critical Theory insists that the economy, society, the state, culture, the psyche and thinking all change historically because of their social connections. Horkheimer insists that although this resulted in a sort of intellectual map of the social totality, a truly *historical* materialism precludes finished systems (Horkheimer, 1982: 226–28, 242–43).

Unlike Lukács, then, the interdisciplinary materialism of Critical Theory does not seek to elaborate a final theory of the social and historical totality, but to arrive at some provisional results in order to guide human emancipation. Both Adorno and Horkheimer rejected Lukács idea that the proletarian party was the key to liberation because it supposedly performed a special historical role that lent it privileged insight into the social totality. Accordingly, Critical Theory does not seek to create a collective force that can know society and transform it at the same time by acting as a sort of philosophical super-subject. Instead Adorno's philosophy increasingly focuses on historical individuals rather than a collective subject and concentrates on the suffering of human beings rather than the formation of a socialist party.

Indeed, Adorno goes beyond Horkheimer's methodological criticism of Lukács' concept of totality, to articulate a principled opposition to the category itself. 'Whoever chooses philosophy as a profession today,' he writes, 'must first reject the illusion that

earlier philosophical enterprises began with – that the power of thought is sufficient to grasp the totality of the real' (Adorno, 1977: 120). The truth can only be located in the 'traces and ruins' of the totality, in the fragments that resist integration into a social reality characterised by an authoritarian state and managed economy. For Adorno, the real totality is capitalist society, and it threatens individuals rather than liberating them. In this connection, he speaks of 'our totally organised bourgeois society, which has been forcibly made into a totality' (Adorno, 2007b: 25).

Adorno's opposition to the totality of an organised form of capitalism is informed by the Institute's research documenting an alarming shift to political authoritarianism in the 1930s and 1940s. There was general agreement within Critical Theory that liberal capitalism, with its reliance on market mechanisms and the minimal state had become historically exhausted by the beginning of the twentieth century. The capitalism described by Marx had been replaced by huge conglomerates, international banking and the interventionist state, which sought to manage crisis tendencies through rational planning. This had produced phenomena unknown to Marx, including fascist dictatorships, economic depression and the emergence of consumer society, multinational corporations and the bureaucratic state. One of the Institute's leading economists, Friedrich Pollock, describes post-liberal capitalism as a form of centrally planned 'state capitalism', with democratic (USA, France, UK) and totalitarian (Germany, Russia) variants (Held, 1980: 58–63). Adorno and Horkheimer explain this in terms of the universality of the equivalence principle, the capitalist principle of abstract equivalence and quantitative calculation (Adorno and Horkheimer, 2002: 81–82). According to their analysis, 'universal equivalence' has spread throughout society because of the monetarisation of social relationships, generating an integrated, one-dimensional society. At the same time, the equivalence principle in state administration means the growth of an extensive bureaucracy, tightly linked to the economy.

Rationality itself begins to reflect the ubiquity of mathematical calculation, turning into a domineering sort of formalistic universality, lacking contact with the particulars of human existence. In the philosophical idea of 'determining judgement', where reason categorises particular cases under universal rules, Adorno and Horkheimer find the blueprint for a real social procedure that catalogues and disciplines individuals (Adorno and Horkheimer, 2002: 64). The liberal individual of the nineteenth century, who belongs to the era of free trade and the minimal state, no longer fits into the 'administered society'. Increasingly, the unique personality and moral autonomy of the individual becomes a problem. The twentieth century witnesses the rise of widespread consumerist hedonism, together with of new, conformist personality types that can be squeezed into the mould of post-liberal capitalism. The totality, for Adorno, turns out not to be a category of revolution, but the intellectual model for totalitarianism.

The culture industries

The second major disagreement with Lukács' perspective flows from the idea that capitalist society has become an administered world. Culture and the psyche, Adorno and co-thinkers argue, have been integrated into the state capitalist totality, through the mechanism of universal equivalence. This results in changes in the historical form of personality structure, with a shift away from the autonomous individual toward a compliant form of subjectivity. It also results in the emergence of the 'culture industries', as the cultural complement to the administered society. A leading consequence of Adorno's idea of the emergence of culture industries in the late nineteenth century and early twentieth century is that artistic realism has become highly conservative.

The expression 'culture industries' is potentially misleading, because it can be misunderstood as a complaint against the commercialisation of art. Such a position would end up

opposing 'bad', commodified mass culture to 'good', non-commercial high art, in a highly simplistic way. That would indeed belong to a 'mandarin cultural conservatism' consonant with elitist theories of cultural degeneration (Jay, 1984: 17). But Adorno's actual position is that art in the modern world (that is, from about 1500 onwards) has always been connected to art markets (Adorno and Horkheimer, 2002: 107–9). Adorno's claim is that with the rise of post-liberal capitalism, cultural production has become subjected to profit-directed industrial methods and this has altered the internal structures of the work of art. So-called realist art becomes a generic convention that no longer describes the social world, but instead provides escapist compensations for socially conforming individuals.

To grasp the implications of Adorno's position, we need to look briefly at an important essay on realist art by Adorno's co-thinker, Herbert Marcuse. Not only does Marcuse formulate a quite different interpretation of realism to Lukács, but he also provides the basis for Adorno's reflections on modernism. Marcuse states in his essay entitled 'Affirmative Culture' that bourgeois art became secularised because of a shift from religious functions to art markets (Marcuse, 1968: 95–115). This is part of the meaning of the idea of the 'autonomy of art'. Artists' financial independence went together with a shift in the social role of art, from being an expression of faith to being a reflection of nature and society. Artists turned away from stereotyped religious set-pieces to the lively world of everyday life, seeking to accurately capture the details of the particular individuality of their models, from a perspective that expressed the unique style of the artist themselves. Not surprisingly, the artists of the sixteenth and seventeenth centuries lacerated the pretensions of the old order, contrasting its empty formality and outdated dogmas with the substantive ideal of the full self-realisation of the individual that their own work embodied. The cultural conventions of late feudal society were not undermined by the works' particular political content but by the

formal properties of this new art's affirmation of individuality. As Marcuse argues, this explosively linked a desire for individuation with the need for human happiness in ways that connected realist art with the revolutionary demands of the rising bourgeousie.

By affirmative culture is meant that culture of the bourgeois epoch, which led in the course of its own development to the segregation from civilization of the mental and spiritual world as an independent realm of value that is also considered superior to civilization. Its decisive characteristic is the assertion of a universal, obligatory, eternally better, and more valuable world, that must be unconditionally affirmed: a world essentially different from the factual world of the daily struggle for existence, yet realizable in every individual 'from within,' without any transformation of the state of fact. (Marcuse, 1968: 95)

Marcuse does not directly equate bourgeois art with realist aesthetics until *The Aesthetic Dimension* (Marcuse, 1978). But that is what this autonomous, secular, art of everyday life, with its built-in utopian ideals of individuality and universality, actually is. Marcuse holds that bourgeois, realist art, is historically special because of two distinctive properties. Firstly, it is deliberately useless, which means that art is an end in itself, an item that does not have a use value and is not produced primarily for the sake of profit. Autonomous artworks are therefore analogous to liberated individuals, since both are free particulars that 'self-legislate' though their form, in order to achieve ends inherent to themselves rather than goals imposed from without. Secondly, what art is produced for is in order to release the peculiar sort of pleasure that is produced by a special class of things that have the form of organic totalities. The harmonious balance in artworks between the parts and the whole that is characterised as 'the beautiful' happens because although the whole is greater than the sum of its parts, none of the parts are arbitrarily subjugated to the total conception. For Marcuse, the pleasure that aesthetic beauty releases is different to instrumental satisfaction of instinctual

needs and it raises a 'promise of happiness' because of its implicit vision of individual fulfilment under conditions of universal liberty and general prosperity (Marcuse, 1968: 115). 'Art,' writes Adorno, echoing Marcuse, 'and so-called classical art no less than its more anarchical expressions, always was, and is, a force of protest of the humane against the pressure of domineering institutions' (Adorno, 1992: 293).

As soon as capitalist society had completely erased the residues of the feudal order, however, bourgeois art lost its unequivocally radical potential because its vision of individuality now lacked a critical relation to social arrangements. Instead of a revolutionary confrontation of medieval limitations, realism's representation of individuality tended to promote the ideological illusion that capitalism had delivered on art's promise of happiness. Once the mainstream of bourgeois art lost its critical negativity toward society it became increasingly flabby, an official, 'affirmative culture' of generic repetitions and established conventions.

Fascinatingly, then, Adorno and Marcuse substantially agree with Lukács on the role and significance of bourgeois, realist art, at least up to 1850, and indeed, provide a deeper philosophical justification for its importance. Their big difference lies in the fact that Adorno and Marcuse *historicise* realist art, whereas Lukács regards it as a universal recipe for progressive art. For Adorno in particular, Hollywood's cinematic realism, the novelistic realism of Roman Rolland (a favourite of Lukács') and so forth, are now *degenerate* imitations of bourgeois art. It might look like realism, but it is actually just recycled clichés. In Adorno and Horkheimer's most radical argument, the industrialisation of cultural production brings about the entry of the logic of the commodity into the very structure of the artwork itself (Adorno and Horkheimer, 2002: 114–15).

The trivialisation of artistic content characteristic of the entertainment industries flows from the production of profitable

diversions from workplace routine and everyday boredom. For Adorno and Horkheimer, then, the combination of industrialisation and commercialisation of the cultural field transforms mainstream art into standardised light entertainment, characterised by generic clichés, stereotypical contents and repetitious forms that are designed to elicit routine responses (Adorno and Horkheimer, 2002: 107–12). In place of the singular identity of the autonomous artwork, the products of the culture industry exhibit a form of pseudo-individuation that depends on market positioning through brand difference (Adorno and Horkheimer, 2002: 102–18). Real diversity and the anticipation of reconciliation are replaced by the star system and instant gratification, which implies a disturbing form of pleasure based in competitive individualism that involves quasi-sexual rewards for successful aggression (Adorno and Horkheimer, 2002: 120–25). Where once art had spoken the truth to power, it now adapts itself to social reality by avoiding the risks involved in genuine experimentation, providing repetition of the familiar instead of fresh perceptions, new feelings and alternative values (Adorno and Horkheimer, 2002: 125–28). 'As the demand for the marketability of art becomes total, a shift in the inner economic composition of cultural commodities is becoming apparent,' Adorno and Horkheimer conclude. The need for unchallenging diversions that enable recovery from the exhaustion generated by the market society entrench cultural conventions. 'In adapting itself entirely to need, the work of art defrauds human beings in advance of the liberation from the principle of utility' (Adorno and Horkheimer, 2002: 128).

Freudian psychoanalysis

Under conditions of the real totality of the administered society, and in the context of the culture-industrial standardisation of artworks, the organic totality of realist art loses all critical power.

It becomes an escapist compensation that, when wished for *as escapism*, responds to a deeply regressive longing for totality with authoritarian implications, suggesting a sort of individual who is oriented to social conformity rather than individual autonomy. At the same time, the individual who refuses to fit in becomes a rarity, because powerful forces conditioning the socialisation of conformist personalities are present in childhoods regulated by the combination of administered schooling and the culture industries. As far as Adorno is concerned, in the personal domain, only those aspects of the self that have not been completely socially conditioned represent impulses, emotions, feelings and motivations that remain spontaneous and unique. In the social world, meanwhile, only 'the uncalculating autonomy of works which avoid popularisation and adaptation to the market' (Adorno, 2007a: 190) preserves an arena of non-conformist resistance to these cultural pressures. Today, Adorno argues, 'a successful work...is not one which resolves objective contradictions in a spurious harmony, but one which expresses the idea of harmony negatively by embodying the contradictions, pure and uncompromised, in its innermost structure' (Adorno, 1967a: 32). The artwork that refuses to suppress its own contradictions is akin to a slip of the tongue, or what is called in speech act theory a 'misfire', a statement that goes awry. In it, something arising from the natural and unconditioned aspects of the artist's personality, something that is more elemental than conscious adherence to the formal conventions of harmonious proportionality, forces its way to the surface.

Not surprisingly, then, Adorno turns to Freud to understand how this works, and this is the third major difference with Lukács. For Lukács, Freudian psychoanalysis is part of a bourgeois tendency to irrationalist philosophy. He believes that Freud expresses a pessimistic anthropology that is really an ideological naturalisation of capitalist individualism (Lukács, 1980: 230). There are two important points to consider here.

Firstly, the charge of 'irrationalism' relates to Freud's discovery of the instinctual forces that are expressed through the pleasure principle, which is dynamised by unconscious (erotic and aggressive) drives, or the id. Lukács expresses a very common misconception about psychoanalysis, which is that Freud is proposing that human beings are driven by irrational urges and therefore lack the ability to conduct themselves rationally on the basis of their moral autonomy. Freud most certainly says that 'the ego is not even the master in its own house' – it governs, but does not reign. But he explains this by claiming that:

The ego seeks to bring the influence of the external world to bear upon the id and its tendencies, and endeavours to substitute the reality principle for the pleasure principle, which reigns unrestrictedly in the id. For the ego, perception plays the part which in the id falls to instinct. The ego represents what may be called reason and commonsense, in contrast to the id, which contains the passions. (Freud, 1984: 364)

The ego is involved in a balancing act, between the pressure of the id, the constraints of reality and the conformist demands of the superego (i.e., the individual's moral conscience, based on a beloved image of authority). As Adorno understands it, the intention of psychoanalysis is to 'drain the sea' of the irrational drives by strengthening the ability of the ego to cope with reality. It achieves this neither by fortifying the ego, nor by reinforcing the punishments of the superego, but by re-integrating split-off unconscious drives into the dynamic equilibrium of the individual's personality structure, achieving thereby a new balance. Psychoanalysis is about generating a higher equilibrium within the individual, promoting a balanced relation between reason and the passions through ego maturity. The ideal of psychoanalysis is the reintegration of the components of the personality structure into a non-antagonistic equilibrium that facilitates, rather than sabotages, individual autonomy (Adorno, 1967b: 82). Mind you, Adorno is critical of

the 'ideal of integration' when this excludes the idea of social transformation:

The well-balanced person who no longer sensed the inner conflict of psychic forces, the irreconcilable claims of id and ego, would not thereby have achieved a resolution of social conflicts. He would be confusing his psychic state – his personal good fortune – with objective reality. His integration would be a false reconciliation with an unreconciled world... The 'good' Freudian, uninhibited by repressions would, in the existing acquisitive society, be almost indistinguishable from the hungry beast of prey and an eloquent embodiment of the abstract utopia of the subject. (Adorno, 1967b: 83–84)

Secondly, the implication of Freud's concept of the ego is to frontally challenge the philosophical abstraction of the 'transcendental subject'. Unlike the transcendental subject, which appears fully formed to 'create the totality of contents' of the world (Lukács, 1971: 142), the ego is formed through the process of socialisation. The implication is that transformations in culture and society that lead to new forms of socialisation have the potential to significantly affect personality structures, by altering the course of ego-formation.

For Adorno, Freud's conception of the instincts is the ballast that prevents psychoanalysis from thinking that the ego might successfully adapt to social reality (Adorno, 1967b: 86–88). According to Freud's libido theory, the human animal adapts to its natural and social environment through the formation of a psychic structure – the ego – that reflects a 'precipitate of abandoned object-cathexes' (Freud, 2001b: 29). From this perspective, the reality principle, operating through the ego, disciplines the expression of the pleasure principle that operates in the entirely unconscious id, by forcing it to accept delayed gratification in accordance with the dictates of external reality. In effect that means that the socialisation of the infant involves the renunciation of satisfying objects, especially sexual objects, and the

'precipitation' of these sacrifices in the structure of the personality. Freud proposes that a portion of libido is permanently invested in the ego as 'desexualised narcissistic libido' around each conquest of repression, and he eventually described this precipitated structure as the superego, the psychic representation of social ideals. Stages of development, Freud holds, are deposited in the ego as personality structures that reflect fundamental attitudes of the ego toward the libidinal strivings of the rest of the psyche (Freud, 2001b: 1–66; Freud, 2001a: 141–58).

Freud holds that the superego, representing moral ideals and social norms, assists the ego in the repression of anti-social impulses, especially tabooed sexual urges. These repressed sexual impulses form the basis for unconscious wishes, which indirectly resurface in the 'return of the repressed', as symptoms, inhibitions and anxieties. In order to prevent the direct resurfacing of the dark underside of individuals' attachments to authority, the superego draws upon the forces of aggression located in the id, and uses this to punish the ego for its supposed transgressions. Freud's essay on *Civilization and its Discontents* (1930), which deals with the historical rise of the superego, made a tremendous impression on Adorno. In that extraordinary work, Freud proposes that the advance of civilisation was necessarily accompanied by the increasing 'renunciation of instinctual satisfactions'; that is, historically developing social reality demanded the delay of gratification on an ever-expanding scale (Freud, 2001c: 57–146). This condition, which Freud with dark irony calls 'secular progress in repression', means that industrial capitalism has become a sickness-inducing society filled with potentially neurotic individuals, whose resentment of the demands of constant increases in productivity is likely to erupt in volcanic outbreaks of irrationality. What Adorno calls the 'authoritarian personality' is an extreme result of the repressed underside of modern individuals' relation to

authority, where the discontents of civilisation play out through attachment to authoritarian figures who sanction the scapegoating of minorities.

The alternative to repression is sublimation, which Adorno, following Freud, links to art (Adorno, 1984: 9–13). In his essay on Leonardo da Vinci, Freud linked the sublimation of sexual instincts to Leonardo's intellectual curiosity and artistic creativity. Freud's theory of sublimation proposes that where repression involves idealisation with an unconscious sexual component, sublimation involves idealisation based on a transformation of the goal of the sexual instincts into a desexualised activity. The big difference between repression and sublimation is the relation to social authority. Repression depends on the internalisation of a beloved image of authority that lays down prohibitions and punishes transgressions. This controls the id at the expense of weakening the ego, generating a personality structure that is dependent on external authority for its direction. Sublimation depends upon evolving an imagined goal whose achievement is deeply satisfying for the individual, and which, although it lies in the field of culturally accepted activities (e.g., art and science), makes no reference to prohibiting authority. This generates independent ego structures with personality types likely to clash with any authority figures who seek to control activities happening in the cultural field (e.g., Galileo's science and the Catholic Church, Leonardo's art and the Medici family). Adorno's concept of artistic mimesis is complicated and sometimes unclear, but it definitely involves an unconscious libidinal attachment to the object (Sherratt, 2002: 155–74). Adorno's comments in *Aesthetic Theory* on Freud and art suggest that mimesis is best understood as his interpretation of sublimation.

From Enlightenment rationality...

Against the background of these three major differences, Adorno and Lukács' opposed positions on the Western European Enlightenment are a touchstone for their respective stances on realism and modernism. Lukács believes that progressive thinkers must resume the project of Enlightenment, including its realist art, which the bourgeoisie abandoned as it became a conservative force. By contrast, Adorno thinks that the Enlightenment is part of the problem, because its ideal of technological progress through forms of knowledge that reduce the world to a mathematic formula has led to the administered society, the culture industries and an increasing repression of human nature in the psychic lives of modern individuals.

Adorno's interest in Freudian psychoanalysis was initially sparked by his inquiry into the irrational support for political authoritarianism in the interwar years. It deepened in the claustrophobic atmosphere of social conformity that emerged in the postwar era. But its unexpected result was that Adorno was led to question the facile idea of progress held by Marxists like Lukács. Freud's notion of 'secular progress in repression' through increasing 'instinctual renunciations' seriously dented faith in technological development and any confidence that the transformation of nature through human labour was automatically positive. The implication of psychoanalysis is that technological mastery of nature is achieved at the expense of the inner nature of human beings, and that this is the deepest meaning of the instrumentalisation of the natural environment and human society identified by Lukács.

Accordingly, Adorno's concept of 'instrumental reason' combines commodity reification with psychic repression, in an explosive critique of social domination and the mastery of nature that indicts labour as well as commodification. 'Humanity had to inflict terrible injuries on itself,' Adorno and Horkheimer write, 'before the self, the identical, purpose-directed, masculine

character of human beings, was created, and something of this process is repeated in every childhood' (Adorno and Horkheimer, 2002: 26). Instrumental reason, then, links cognitive understanding to technical controls, through forms of knowledge that seek a mastery of nature by reducing it to something mathematically predictable and therefore potentially subject to human intervention. This implies a significant critique of the Marxist tradition, for instrumental reason arises first and foremost in the process of the transformation of nature, in line with survival instincts, that happens in labour. Accordingly, the idea that technological progress has an automatically liberating dynamic linking the increase in material prosperity to social freedom becomes a central target for Adorno's critique.

The enslavement to nature of people today cannot be separated from social progress. The increase in economic productivity which creates the conditions for a more just world also affords the technical apparatus and the social groups controlling it a disproportionate advantage over the rest of the population. The individual is entirely nullified in the face of the economic powers. These powers are taking society's domination over nature to unimagined heights. While individuals as such are vanishing before the apparatus they serve, they are provided for by that apparatus better than ever before. In the unjust state of society, the pliability and powerlessness of the masses increase with (this) materially considerable but socially paltry rise in the living standard of the (working) classes. (Adorno and Horkheimer, 2002: xvii)

In the *Dialectic of Enlightenment*, Adorno and Horkheimer set out 'to explain why humanity, instead of entering a truly human state, is sinking into a new kind of barbarism' (Adorno and Horkheimer, 2002: xiv). To do this, they reconstruct the anthropological genesis of instrumental reason. The basic aim of 'enlightenment', in line with its underlying instinctual thrust, is the mastery of a threateningly unknown and potentially deadly nature. Drawing on psychoanalysis, they propose that the flipside to this is a

tendency to regard the unknown as the uncontrolled and to respond with pre-emptive aggression to the potential threat. Accordingly, the ideal of progress, which dispersed the myths of medieval religion, in turn zeroes in on what appear to be dangerous residues of nature in so-called races and natural feminine sexuality, generating dark new myths of anti-Semitism and anti-feminism (Adorno and Horkheimer, 2002: 86–88). They formulate this as a paradox:

Enlightenment…aimed at liberating human beings from fear and installing them as masters (of nature). Yet the wholly enlightened earth is radiant with triumphant calamity.…With the extension of the bourgeois commodity economy, the dark horizon of myth is illumined by the sun of calculating reason, beneath whose cold rays the seed of the new barbarism grows to fruition. Under the pressure of domination, human labour has always led away from myth – but under domination always returns to the jurisdiction of myth. (Adorno and Horkheimer, 2002: 1, 32)

It often seems that *Dialectic of Enlightenment* is proposing a tragic dialectic, according to which enlightenment provides human beings with power to master nature, but that very potency turns upon human beings and enmeshes them in the domination of one another. But that is the dialectic of instrumental rationality. According to both Marx and Hegel, the dialectic of domination and liberation gradually ascends to general emancipation, so that the master narrative of historical progress culminates in universal freedom. The goal of history is therefore the convergence of the potential for freedom with the actualisation of emancipation. Combining the dialectic of domination and liberation with a Freudian perspective, however, results in a sea change. Now the potential for freedom and the actualisation of emancipation diverge, because every apparent achievement of freedom is accompanied by increasing repression of instincts. Human happiness is in inverse proportion to political liberty, so

that the personality becomes cold and calculating, and individuals irrationally resent society's demands.

But Adorno's dialectic responds to this divergent dialectic of instrumental rationality. The inverse of the bleak perspective opened by instrumental rationality is a massive unrealised potential for emancipation: the dark night of the totalitarian mid-century may turn out to be the vanishing moment of utter blackness presaging a new dawn. Such a position implies that there is instrumental rationality and its potentially totalitarian 'enlightenment', but there is also dialectical reason and its emancipatory *enlightenment* (Adorno and Horkheimer, 2002: 23). Likewise, there is the mastery of nature springing from self-preservation, exemplified by the labour process, but there is also a post-capitalist reconciliation between human beings and the natural environment, best expressed through creative praxis. In *Negative Dialectics*, Adorno outlines the basic categories of this divergent dialectic between a universal history of domination and the particular moments of hope that emerge in its interstices.

...to negative dialectics

Adorno's conception of a negative dialectic is complex, and only its central conclusions for aesthetics can be discussed here. For a thinker such as Marcuse, positive dialectical reason can be straightforwardly opposed to instrumental rationality. Indeed, he argues that Hegel's distinction between the formal classifications of the Understanding and the dialectical logic of Reason embodies this opposition (Marcuse, 1999). Why, then, did Hegel's dialectic arrive at a final system whose conclusion was that capitalist modernity represented the 'end of history'? Marcuse responds that Hegel's problem was idealism: the application of dialectical reason within a materialist framework, in line with Marx, will prevent the generation of a theology of progress of the sort that Hegel produced. For Adorno, this is hopelessly simplistic: Hegel's dialectical version of identity

thinking cannot be undone merely by filling up the same philosophical form with a different content, as if subverting identity thinking was just a matter of colouring-in with different crayons. If materialism means anything, it is that concepts cannot fully grasp material particulars, qualitative differences and the embodied experience of the individual.

Accordingly, Adorno begins *Negative Dialectics* with the claim that 'that title initially says nothing more, than that objects do not fully fit into their concepts, that objects cause a contradiction within the traditional norm of correspondence' between concept and object (Adorno, 1966: 14–15; Adorno, 1973: 5). A real philosophical materialism does not involve a new system built on some metaphysical speculations on 'universal matter in motion'. It involves the painstaking investigation of how embodied experience of material existence *has already* left its mark in the contradictions and failures of traditional philosophy, including the positive dialectics of Hegel (and to some extent, Marx). Hence, much of *Negative Dialectics* is an interrogation of the limitations of Kant, Hegel and the philosophical canon, in light of the experience of the encounter with objects that cannot be forced into the framework of concepts, without leaving some remainder.

A *negative* dialectics, as opposed to the positive dialectic of Hegel and Marx, must be a dialectical reasoning that diagnoses moments of contradiction in logic and society as evidence for the encounter between thinking and materiality. Negative dialectics refuses to resolve the contradictions in experience, and instead explores their ramifications for the disruption of 'identity thinking' – meaning both instrumental rationality and positive dialectics. Negative dialectics is, accordingly, an effort to think the 'non-identical' without coercing the experience of perplexity that this implies into a finished system. Speaking of the process of judgement by which objects are subsumed under concepts, Adorno writes:

Objective contradiction designates not only the leftover of an existent entity that remains outside of judgement, but also something within the judgement itself. For judgement means that an existence is brought within the cognitive act as a particular – otherwise, the intention to judge would be superfluous. ... (Accordingly) dialectical contradiction is neither the mere projection of misfired conception formation onto the thing, nor metaphysics run wild. (Adorno, 1966: 153; Adorno, 1973: 152)

As J.M. Bernstein has proposed, Adorno's strategy is to retrieve the repressed forms of substantive judgement or 'material inference' hidden beneath identity thinking. The form of judgement built into identity thinking is what Kant called 'determining judgement', the subsumption of particular cases under universal rules. But this rests upon a repressed initial judgement that is *primitively aesthetic* in character, that the buzzing confusion of perception is in actuality a phenomenal thing, is a unified object. In the process of human beings learning about the world, this leads up to what Kant called 'reflective judgement', the invention of universal principles from particular cases, when these material particulars are taken as so qualitatively different that they generate exemplary, new experiences. The aesthetic judgement of taste, that happens in modernist artworks, 'rehearses in an unconstrained way the reflective judgment that happens *before* determinative judgment in empirical cognition' (Bernstein, 2001: 316).

Adorno's concept of mimesis is the key then to both his negative dialectics and his aesthetic modernism. Mimesis simply means 'imitation', and Adorno believes that this is natural behaviour for human animals. It is equivalent to the idea of reflective judgement. Mimesis lies at the heart of perception because it is installed in the core of all judgements, in the moment in which a thing is perceived: the subject 'imitates' the object *as a thing* by the mere fact of formulating the judgement, 'that is a thing'. In Adorno's anthropological reconstruction of the natural history of human society, mimesis splits into two components.

One is the history of knowledge: magic, metaphysics and modernity employ aesthetic reflective judgement to learn about things, only to place this pre-cognitive knowledge at the disposal of determining judgement, and therefore identity thinking and instrumental rationality, the mastery of nature and the domination of human beings. The other is the history of art: here, reflective judgement flourishes for its own sake, but, because artworks are imaginative constructions, it invents universal principles on the basis of particular cases that are not identical with the empirical world. Therefore, in the reflective judgements that happen in art, a 'non-discursive cognition' takes place – the thinking that happens in perceptions of the world occurs, but it leads to universal principles that are not the same as the concepts of propositional reasoning about really existing states of affairs.

Mimesis, then, is a natural activity of human beings that lies at the heart of both identity thinking and autonomous artworks. Negative dialectics restores the mimetic component to dialectical reason, which means that it is akin to the rational construction in modernist artworks. Adorno connects art and philosophy in a way that avoids 'conceptual poetry'; that is, the aestheticisation of reason, or poetry as concept, the reduction of artworks to cognitive statements. This is an extraordinary achievement. Negative dialectical thinking corresponds to the only form of social praxis that refuses calculation and utility, which is the useless labour of modernist artworks. These contain the last glimpse of the potential for a utopian reconciliation in the midst of the administered world.

Chapter 2

Adorno's history of modernism

Adorno believes that the dissonant forms of modernist art are justified by the evolving dialectical relation between the universal and the particular – that is, quantitative generalisations and the qualitatively specific – in contemporary society. For Adorno, the principle of universal equivalence reigns in capitalist society, subordinating the particular in all its forms – the particularity of the unique individual, the particular qualities of material things and the particularity of radically individuated artworks – through intellectual classification operations that are based on the reduction of everything to mathematical quantities, and ultimately, to monetary relations. Although bourgeois classification, which Adorno calls 'identity thinking', regards the universal as primary, for Adorno, the particular comes first. The particular – especially the human individual – remains 'non-identical', qualitatively distinct, despite the fiercest efforts of market economics, authoritarian states and a culture of conformity. But *expressing* that particularity through unique personalities, individualised forms of self-realisation and highly individuated artworks, becomes more and more difficult. As the universal and quantitative, which Adorno calls 'universal equivalence', comes to dominate the qualitative particular, individuality is increasingly suppressed by mechanisms enforcing social conformity. The modernist rebellion artistically expresses resistance to this situation and documents the worsening antagonism between individual and society in the administered world.

Adorno's dialectical opposition between the universal and the particular, the quantified and the qualitative, is very significant for art. Of course, an artist can decide to take their place on the production line in the culture industries, making standardised, pseudo-individuated works. Such works are only quantitatively different from one another (for instance, some are more commercially successful than others) and they gain universal acclaim precisely by sacrificing qualitative distinctness and the particularity of real individuation. But for an artist who decides to defend their own expressive individuality and the qualitative distinctness of their artworks – that is, who locates themselves in the field of autonomous art – there are two possible responses to the 'dialectic of enlightenment'.

- The artist can seek to win new sorts of qualitative distinctness through discovery of hitherto unknown forms of particularity, by *going forward* through the process of rationalisation. Rationally driven revolutions in artistic technique and new understandings of the aesthetic medium create a field of self-expression within which complexes of feeling and insight that have so far been denied social consideration can come to light.
- The artist can seek to defend older sorts of qualitative distinctness that have already been lost through their transformation into quantitative differences, by *regressing backwards* against the process of rationalisation. Rejecting rationally driven artistic techniques and new understandings of the aesthetic medium, the artist attempts to recover now vanished 'authentic' complexes of feeling and insight through intuition and primitivism.

Against this conceptual background, Adorno constructs an ideal-typical artistic continuum composed of two poles, rationalisation and authenticity. His reconstruction of art history is based on the idea of a dialectical conflict between

these two poles, which means that he selectively focuses on a series of artists that he thinks best illustrate the extremes, neglecting the vast majority, who lie in-between. Adorno maintains that these two poles, rationalisation and authenticity, have political implications, for rationalisation is progressive, whereas authenticity is nostalgic and reactionary.

This chapter follows the path outlined by Max Paddison in *Adorno's Aesthetics of Music*, in tracing Adorno's reconstruction of the evolution of music up to the opposition between Schönberg and Stravinsky (Paddison, 1993: 218–78). Then, it clarifies Adorno's schema in visual terms, by looking at a related opposition between the painters Wassily Kandinsky and Emil Nolde. To understand why Adorno, who thinks that instrumental reason is the key *problem* in the administered world, believes that aesthetic rationalisation is politically progressive, it is crucial to remember that he is a thinker of negative dialectics. Aesthetic rationalisation means, primarily, the sort of negative dialectical reason involved in reflexive judgement. This sort of reasoning broadens the range of things that an individual can feel and think, and speak about, even though, in the absence of a major social transformation, these precious discoveries will eventually be surrendered to the workings of the principle of universal equivalence. And Adorno is realistic about the potential for aesthetic rationalisation to become merely the intrusion of instrumental rationality into the artwork. By contrast, aesthetic authenticity is a defensive operation designed to protect whatever can be recovered of earlier, narrower forms of individuality, conducted with anti-rational means. Despite, therefore, actually having a great deal of sympathy for the authentic/nostalgic position (Habermas, 1984: 385), Adorno ultimately believes that it is a lost cause that can only end up promoting totalitarianism because, in the final analysis, its form of individuation is irrational.

Historical dialectics of musical material

Adorno's philosophical reconstruction of the history of music centres on an innovative concept of 'musical material'. He opposes theories that present Western music as entirely natural – for instance, the common idea that the tonal intervals of Western scales correspond to the physiological properties of the human ear. Adorno argues that the musical material – that is, the sound frequencies (i.e., musical pitches), characteristic intervals, musical instruments, orchestral arrangements and written notation of Western music – is historical, in two related ways. Firstly, modern Western music is the product of a historical process of rationalisation (1450–1850), which generates classical, harmonic music from medieval, polyphonic music. Secondly, this rationalisation happens through the technical advances of individual composers, each of whom alters the state of the musical material. According to Adorno's dialectical theory – an extension of his idea of the dialectic of Enlightenment – every composer confronts the historical state of the musical material (i.e., the achievements of their predecessors) as an alien objectivity. It is not really the greatness of past composers that is the problem, but rather that their technical accomplishments deposit in their wake a systematisation of music as a rationally mastered field, one that verges on the reduction of musicality to mathematical formulae.

Technically, we can understand this in terms of the operation of reflexive judgement as the invention of universal principles for particular cases. Although this is liberating, once these have been formulated, it is a simple thing for determining judgement to take over again and begin to submit particular cases to the new rules. Thus, instrumental rationality can accomplish nothing new, but it constantly steps in after the fact and petrifies the accomplishments of dialectical reason. This makes everyday, colloquial sense. The reproduction of the accomplishments of past composers, through the recycling of techniques as

formulae, would amount only to a leaden imitation – that is, an individuality-denying set of musical clichés. In order to express their own subjectivity through the musical material, new composers must transform it, by mastering it in the name of expressive possibilities. This mastery of the musical material, achieved through rationality, yields a new expressivity only at the cost of a further systematisation of the musical material. Thus, the vise of rationalisation closes ever tighter around each successive generation of composers.

Adorno's philosophy of music represents a critical appropriation of Weber's music sociology. In *The Rational and Social Foundations of Music* (1921), Weber presents the idea that music is involved in the process of rationalisation characteristic of modernity. Medieval music was not only religiously inspired, but had a ceremonial function in religious ritual, which lent its polyphonic fugue structures (its multi-voiced harmonies, which developed through set patterns of alteration and repetition, or 'fugue') a rigidly stereotyped, formulaic character. By contrast, from the Renaissance (1450–1650) through to the Enlightenment (1650–1850), Western European music broke with medieval formulae through the application of new, mathematical reasoning processes to harmonic intervals, musical instruments and notation systems. In a very short period, what we know as 'classical music' developed the modern minor and major scales, the piano (with its fixed, 'chromatic', semitone intervals represented by black and white keys), new string and wind instruments, the orchestra arrangement and sonata form, double-stave notation with a commonly agreed set of symbols for notes, each of which has a fixed value, and so forth. Dominance of the 'horizontal' dimension of melody, the succession of notes that comprises a characteristic sequence, or motif, replaced the dominance of the 'vertical' dimension of polyphony, the simultaneous sounding of multiple notes in various combinations. This vertical dimension was itself restricted to a set of harmonies that can be precisely

defined in mathematical terms, described by Adorno as the 'homophonic sonata form'. (A parallel development in painting produced linear perspective, techniques for the preparation and sealing of oil-based paint, conventions for the realistic depiction of the human form and natural world, and a break in the topics of painting from pre-set religious themes to prosaic scenes from everyday life.) Weber is characterised as describing this in terms of 'the drive toward rationality, that is, the submission of an area of experience to calculable rules'. His argument is that 'this drive to reduce artistic creativity to the form of a calculable procedure based on comprehensible principles appears above all in music' (Weber, 1958: xxii).

Weber thinks that this process of rationalisation is completed by 1850, which implies that Western music has perfected itself. Now, unlike painting, for which ideas of compositional balance and colour tonality can only be imprecisely defined, the musical terms 'harmony' and 'tonality', 'consonance' and 'dissonance', can be defined in terms of mathematical ratios. The exact details of how these are defined are less important to us than the brute fact that they can be so determined.

The intervals contained in harmonic triads or their inversions are (either perfect or imperfect) consonances. All other intervals are dissonances. Dissonance is the basic dynamic element of chordal music, motivating the progression from chord to chord. Seventh chords are the typical and simplest dissonances of pure chord music, demanding resolution into triads. In order to relax its inherent tension, the dissonant chord demands resolution into a new chord representing the harmonic base in consonant form...Any dominant seventh chord contains the dissonant diminished triad, starting from the third and forming the major seventh. Both of these kinds of triads are real revolutionaries when compared with the harmonically divided fifths. (Weber, 1958: 3–6)

In keeping with Weber's conservative outlook, the revolution is doomed to fail, so that the Romantic effort to introduce dissonance

by exploiting the major seventh and the minor ninth chords merely represents an exception that confirms the rule (Adorno, 2007b: 52). Adorno, by contrast, understands the *necessity* of the Romantic revolt against what the mid-nineteenth century already called 'classical music'. Indeed, he endorses a radicalisation of their revolt, for he claims that 'to the technically trained ear', the tonal combinations of the homophonic sonata form have become so exhausted as to be impossible to use. 'The most progressive level of technical procedures,' Adorno writes, 'designs tasks before which traditional sounds reveal themselves as impotent clichés' (Adorno, 2007b: 24–25). In this context, the harmonious intervals of classical music are 'cacophonous', and only dissonances preserve any interest.

The revolution of atonal music, including the twelve-tone note row that we have already glimpsed in the Introduction, frees the composer from the restriction of the chromatic scale (i.e., the selection of eight notes from the twelve semitones of the classical major and minor scales). Where classical music has to content itself with a highly limited number of tonal combinations, the modernist composer is no longer constrained by the demands of vertical harmony or tonal melody. Yet this emancipation itself becomes, in keeping with the tragic dialectic that Adorno detects in the development of musical material, a fresh cage:

With the liberation of musical material, there arose the possibility of mastering it technically. It is as if music had thrown off that last alleged force of nature which its subject matter exercises upon it, and would now be able to assume command over this subject matter freely, consciously and openly. The composer has emancipated himself along with his sounds...(But) a system by which music dominates nature results...The conscious disposition over the material of nature is two-sided: the emancipation of the human being from the musical force of nature and the subjection of nature to human purposes. At the same time, however, this technique further approaches the ideal of mastery as domination...Music, in its surrender to historical dialectics, has played its role in this process. Twelve-tone technique is truly the fate of music. It enchains music by liberating it. The subject

dominates music through the rationality of the system, only in order to succumb to the rational system itself…From the procedures which broke the blind domination of tonal material there evolves a second blind nature by means of this regulatory system. (Adorno, 2007b: 39, 47, 49–50)

Artistic material and the autonomous individual

Now let us look at the details of this process in their social context. The same forces that shape the historical fate of the autonomous artwork confront the autonomous individual, and, indeed, because art is a struggle for individuation, the two destinies are intertwined. In broad overview, in Adorno's art history the mutual evolution of individual and artwork follows a narrative of rise and decline.

The Enlightenment philosopher Immanuel Kant (1724–1804) had already defined moral autonomy as individual self-determination through rational reflection on norms of action. Refusing to be dictated to by authorities, the morally autonomous individual acts as a rationally self-legislating person guided only by universal principles. Because every autonomous individual reasons universally – that is, with logical consistency from universal principles – the actions of self-legislating persons all coordinate without the need for an external authority or official religion to coerce them into cooperation. What Hegel's dialectical philosophy added to this liberal vision was the idea that the social conditions for the exercise of moral autonomy as political liberty were provided by a free market economy. This is said to provide social prosperity and therefore human happiness for all, when accompanied by a proactive state guided by a bureaucracy educated in universal principles. Adorno, following Hegel, describes this as the bourgeois ideal of reconciliation between subjective (autonomous individuals) and objective (the whole society).

The period from the French Revolution (1789–94) through to the middle of the nineteenth century is, for Adorno, the triumph of the liberal bourgeoisie in its ascent over the reactionary

aristocracy. But in line with Marx's *Critique of Hegel's Philosophy of Right* (1843), Adorno detects a problem with the Hegelian ideal of bourgeois reconciliation. The market society, instead of delivering human happiness through general prosperity, generates a class society polarised between wage workers and big business. Throughout the nineteenth century, this social polarisation produced spectacular wealth for the propertied class, but conditions of poverty and squalor for the working class. It also produced a militant socialist movement amongst the dispossessed, with progressive demands for voting rights, trade-union rights and social welfare, which eventually lead to intense struggles in the period 1848–52. Marx diagnosed these failed revolutions as the moment when the liberal bourgeoisie abandoned its emancipatory struggle. For Adorno, as for Marx, the progressive historical mission of the bourgeoisie became exhausted at this moment. Adorno proposes that:

The instrument by means of which the bourgeoisie had come to power, the unfettering of forces, universal freedom, self-determination – in short, enlightenment – turned against the bourgeoisie as soon as that class, as a system of rule, was forced to suppress those it ruled. (Adorno and Horkheimer, 2002: 73)

From 1850 to 1950, Adorno argues, the bourgeoisie in power became a conservative class, while society was increasingly submitted to the laws of motion of capitalist economics. Massive industrialisation with the impoverishment of the majority of the population, colonial empires and the first imperial wars – the world described by Charles Dickens – became the alienating 'objectivity' opposed to the 'subjectivity' of autonomous individuality. In the face of an anonymous set of social mechanisms, the individual finds him- or herself unable to really exercise his or her rational capacities for moral autonomy, and is increasingly confronted by a choice between social conformity and retreat into subjective inwardness.

Adorno believes that the fate of art is intimately bound to the destiny of the autonomous individual. In aesthetics, the artwork consists of details (such as notes from a certain key and musical motifs, or individual brushstrokes and compositional elements) and the whole (such as, for instance, an entire sonata, or a completed visual work). The social relation between subjectivity and objectivity, Adorno believes, is expressed through the balance between details and whole in the artwork. When objectivity predominates in society, suppressing the individual's autonomy, artworks tend to display a conceptual wholeness that subordinates the details, leading to artistic schematisation. The protest of subjectivity against coercive objectivity takes the form of the rebellion of the details, where compositional elements begin to clash with the artistic whole.

This process can be traced historically (Paddison, 1993: 220–23). The classical sonata, developed by Handel (1685–1759) and completed by Haydn (1732–1809), but already subverted by Mozart (1756–91), represents an emancipation of music from its religious functions (Adorno, 1976b: 160–74). Adorno proposes that compositionally, the idea of 'motivic development', the repetition-with-alterations of a distinct musical figure or sound phrase, emerges at this stage (Adorno, 1976b: 208). The equivalent evolution in painting is the development of linear perspective up to the realistic representational paintings of the Northern European masters. In particular, Adorno connects motivic development in the secular sonata with the principle of autonomous individuation, because it is the expression of a highly individual fragment that, through its quasi-logical permutations, legislates the form of the work (Adorno, 1976b: 194–218).

During the Enlightenment, there is a gradual synthesis of details and whole in the period of classical bourgeois art, which culminates in the middle of the nineteenth century with reconciled, balanced works. Beethoven (1770–1827), in particular, 'is the musical prototype of the revolutionary bourgeoisie',

whose work is the paradigm of 'a music that has escaped from its social tutelage and is aesthetically fully autonomous' (Adorno, 1976b: 209). Not only is music liberated from religious functions, and therefore institutionally autonomous, but the musical material is emancipated from subservience to purposes of entertainment or ceremony, so that its aesthetic autonomy consists in it providing itself with an 'autarchic motivational context' (Adorno, 1976b: 209). Beethoven achieves this through the systematic development of a motif so that it eventually returns upon itself, as if it had in the first place been generated through the formal necessity of the composition, thus enclosing all of the parts of the work within the charmed circle of a self-generating whole (Adorno, 2002: 162–80). This musical form not only expresses the social reality of the autonomous individual, as a self-legislating rational being, but its harmonious balance of parts and whole, or organic totality, also reflects a fleeting reconciliation of this individual to the social totality. Adorno links Beethoven's organic musical totalities to the intellectual reconciliation of the particular and universal in Hegelian philosophy, arguing that they both express the same historical moment (Adorno, 2002: 162–80).

From late Romanticism to musical modernism

After Beethoven's time, as the social context becomes reified and anonymous, imposing significant constraints on moral action, the autonomous individual preserves their sovereignty by a retreat inwards into late Romantic subjectivity. Intellectual freedom is salvaged by opposing it to social unfreedom; the balanced relation of universal and particular, objective and subjective, social and individual, whole and parts, disintegrates. Dominant artistic forms become 'affirmative culture', including an official repertoire of 'classical music' performed by state symphony orchestras, as the power of bourgeois art to negate unfreedom dissipates into

conventional banalities and artistic platitudes. As a matter of fact, Adorno argues, this process is already anticipated in the final period of Beethoven's work. In 'Late Style in Beethoven' and 'Alienated Masterpiece: The *Missa Solemnis*', Adorno proposes that 'in the history of art, the late works are the catastrophes' (Adorno, 2002: 567) and that, in particular, Beethoven's late mass represents the *disunity* of subjective and objective, in its fragmented citation of musical conventions in opposition to moments of subjective expression (Adorno, 2002). The politically liberal, autonomous individual is alienated from the objective socio-historical context, which begins to confront him or her as resistant to the realisation of individuality.

For Adorno, musical modernism begins in the wake of Beethoven's achievement, with the fragmentation of the formal unity of classical music at the same time as a rationalisation of musical content. In his reconstruction of the process, on the expressive side, the 'lyrical inwardness' of the Romantic composers, especially Schumann (1810–56), intensifies the technique of 'developing variation', exploiting the possibilities of dissonance internal to homophonic music, in an evolution that culminates in Brahms (1833–97). The visual analogue of this process is Impressionism, which exploits the residue of subjectivity present even in the most technically objective realist painting – the perspective of the observer – and develops this into a painting of the act of perception. Adorno claims that the idea that Brahms bears

the mark of bourgeois society's individualistic phase is indisputable enough to have become a platitude. In Beethoven, the category of totality still preserves a picture of the right society; in Brahms it fades into a self-sufficiently aesthetic principle for the organisation of private feelings. (Adorno, 1976b: 63–64)

The other line of musical development involves an effort to renew music through the introduction of external, 'non-artistic' sounds

into the musical material. Beginning with Berlioz (1803–69), incidental music from non-symphonic sources – fairground bells, trumpet flourishes, industrial horns and so forth – is integrated into the texture of works. Such a process culminates in the twentieth century in the art music of John Cage, for instance, where incidental ambient noise entirely replaces deliberate musical sounds. The equivalent in painting is, of course, the techniques of montage and collage.

This line leads up to Wagner's 'total work', which Adorno interprets as a highly contradictory development opposed to Brahms' achievement. On the one side, Wagner drives forward the disintegration of the musical material because he represents a new peak in the introduction of non-symphonic sounds into the musical texture. On the other side, the integration of incidental sounds, spoken words, prop noises and so forth, into Wagner's total operas, submits these things to the process of rationalisation. As Paddison points out, there is no doubt that Wagner engages in a progressive rationalisation of the technical structure of the musical material, involving motivic and harmonic construction, refinement of orchestral technique and evolution of new instruments, the sense of time and the integration of music with drama (Paddison, 1993: 243). Yet Adorno thinks that Wagner's technical progress is deployed in the service of expressive reaction, specifically, that Wagner seeks to make the artwork so seamless that it appears natural (Adorno, 1981: 82–97). This implies a conservative desire to recover a 'natural', authentic form of life as an enchanted alternative to the modern world, one that, because 'natural', is overpowering and monolithic (Adorno, 1981: 91). On Adorno's interpretation, like the sorcerer's apprentice, this transforms cultural materials into a second nature that then dominates the wielder:

The parable of the man who dominates nature only to relapse into a state of natural bondage gains an historical dimension in the action of (Wagner's opera) *The Ring*: with the victory of the

bourgeoisie, the idea that society is like a natural process, something 'fated' is reaffirmed. (Adorno, 1981: 137–38)

The effort to re-enchant society extends right down into the musical 'cells', for Adorno maintains that the ideal here is to represent the musical work as a fragment of nature. Wagner's motifs masquerade as having the ontological dignity of items drawn from the fundamental table of the chemical elements, making them into anticipations of twentieth-century existentialist ideas about metaphysical Being (Adorno, 1981: 31–47). But, Adorno suggests, this is not entirely successful, for the ideal of total unity is belied by the static and unintegrated character of each of these motifs, so that, upon inspection, the 'total work' breaks apart into a constellation of fragments. Further, many of these motifs are fairly trite – the development of an incidental trumpet flourish into an entire motif, and its expansion through development into a whole musical sequence, for instance – reflecting showy commercialised entertainment without much lasting artistic import. What *that* suggests, for Adorno, is that Wagner's work actually reflects a process opposed to the rationalisation of the musical material undertaken by Brahms. Adorno thinks that the integration of secondhand clichés into art music in an effort to bewitch the audience implies the commodification of musical material, so that Wagner contains the antagonistic poles of Romantic expression and commercial entertainment.

The opposition between Brahms and Wagner in the late Romantic period anticipates the central structuring opposition of Adorno's analysis of musical modernism, between Schönberg and Stravinsky, as we will now see.

Schönberg and rationalisation

Schönberg illustrates the 'rationalisation' pole of Adorno's art continuum. The problem confronting Schönberg is that tonal music in its totality has been socio-historically falsified and become a set

of cultural clichés (Adorno, 2007b: 25). His solution is the twelve-tone row procedure, known as 'serialism', or the 'dodecaphonic' rationalisation of the musical material, which makes possible the breakthrough from classical harmony to atonal composition.

It is absolutely crucial to understand that the twelve-tone note row is a preparation of the material and not the compositional process, any more than the Impressionists' technique of using small dots organised through colour theory is the same as the composition of an individual painting. Webern, for instance, is 'bad serialism', because his final works are merely 'schemata of the rows translated into notes'; that is, the preparation of the material has usurped the process of composition and become a sterile formula (Adorno, 2007b: 81). Schönberg, by contrast, is great not because he produces a technical innovation that improves the rationality of music, by breaking with the supposed naturalness of the harmonic scales and thereby extending technical control to the 'irrational' dissonances generated beyond them. He is great because he composes sonatas of incredible expressive power which simultaneously transcend and preserve the classical tradition, through systematic variation within an entirely new framework, and which speak to the deepest experiences of the individual in the first part of the twentieth century.

Adorno's interpretation of serialism depends upon grasping its break with the classical integration of the parts into the whole as a protest that expresses the lonely suffering of the modern individual, trying to communicate across an 'abyss of silence which marks the boundaries of its isolation' (Adorno, 2007b: 29, 88). Schönberg's *Erwartung*, for instance, dramatises sexual impotence in the context of romantic fiasco: it expresses 'gestures of shock resembling bodily convulsions ... and a crystalline standstill of the human being' possessed by anxiety (Adorno, 2007b: 30). Generalising this insight, Adorno proposes that:

The subject of modern music, upon which the music itself presents a case study, is the emancipated, isolated, concrete subject of the late bourgeois era. This concrete subjectivity, and the material which it so radically and thoroughly shapes, supplies Schönberg with the canon of aesthetic objectification. (Adorno, 2007b: 41)

There is a sense in which serialism is total alienation and absolute repression. 'The technical procedures of composition,' Adorno writes, 'which make music into a picture of repressive society, are more advanced than the procedures of mass production which march beyond modern music... serving repressive society' (Adorno, 2007b: 84). At the same time, when reality pretends to be harmoniously reconciled, the unreconciled representation of the truth denounces that reality, so that 'it is only in a fragmentary work that has renounced itself that the critical substance is liberated' (Adorno, 2007b: 93).

Adorno, then, thinks that there is both critical potential and a tragic dialectic at work in Schönberg's rationalised music. Despite his admiration for Schönberg and preference for serialism in modernist music, Adorno does not hold back from a devastating analysis of the way that this break with convention itself tends to congeal into a new objectivity, just as forbidding as the one it replaced. Twelve-tone technique demands the selection of a row of arbitrarily selected tones in sequence, and the compositional rule is that all twelve must sound (in whatever order) before a new group can emerge. Adorno is particularly struck in this context by the way in which compositional choices narrow to nothing as the composer exhausts the twelve notes in any specific musical sequence, either 'horizontally', in the melody, or 'vertically', in the polyphony. Logical deduction threatens to eliminate playful spontaneity, in a startling demonstration of what Adorno means by the 'alienation' of the expressive subject in its own objectified externalisation of subjectivity. The blind submission to the logical consistency of the compositional procedure determines not only its transformation from a

preparation of the material into a rule for the production of compositions, but also a logic of shrinking expressive possibilities in the space where new modes of expression had just appeared.

The abstractness not only of these rules, but of their substratum as well, has its origin in the fact that the historical subject is able to achieve agreement with the historical element of the material only in the region of the most general definitions... Only in the mathematical determination through the row do the compositional will and the claim to continual permutation, which appears historically in the material of the chromatic scale – that is to say, the resistance to the repetition of tones – concur in the total musical domination of nature as the thorough organisation of material. It is this abstract reconciliation which, in the final analysis, places in opposition to the subject the self-contained system of rules in the subjugated material as an alienated, hostile and dominating power. This degrades the subject, making it a slave of the material, as of an empty concept of rules, at that moment in which the subject completely subdues the material, indenturing it to its mathematical logic... For in twelve-tone technique, the rationality of the material... asserts itself blindly over the will of the subjects, triumphing thereby as irrationality. (Adorno, 2007b: 87)

The self-expression of artistic subjectivity under these conditions means its disciplining by the method of rational construction itself, so that it experiences a loss of freedom in the very moment of its apparent liberation from conventionality. The result is that the compositional procedures of the note row extend throughout the musical material, as rational construction eliminates everything conventional, subjecting modernist music to a combinatorial aesthetic. There is plenty of potential here, especially amongst Schönberg's followers, for a 'dazzlingly hermetic music' to become nothing more than a complete 'atomisation of sound' (Adorno, 2007b: 62). Adorno's analysis of this dialectical process of opening and closing expressive possibilities is subtle, suggestive of a sort of process of squeezing, where rationalisation wrings irrational residues

from the subject, transforms them into expressive possibilities through technical innovation, only to leave the subject wrung out, empty and hollow. For new expressive possibilities to be won, the subject must be squeezed even harder in the next round. For Adorno, the total consistency of Schönberg's music becomes an iron cage for the expressive subject, who finds itself rationally dominated by the musical material it had sought to rationally dominate. This is the process of 'enchaining music by unchaining it' through liberation as domination.

Stravinsky and authenticity

The opposite pole to 'rationalisation' is 'authenticity', and in the second half of *Philosophy of Modern Music*, Adorno launches a polemic assault on Igor Stravinsky's work, especially the *Rite of Spring* (1913). For Adorno, Stravinsky deploys the techniques of modernism against the intentionality of the alienated subject, seeking to recover authentic expression by regression to the primitive, infantile and collective. Adorno's highly critical treatment of Stravinsky is motivated by three considerations:

(1) Instead of bringing alienation to self-consciousness and actively seeking reconciliation, intellectual regression accepts alienation and seeks compensation in collective rituals, something with frightening political implications in the 1930s.

(2) Instead of developing the musical material through rational construction, aesthetic regression merely raids the existing repertoire of techniques in search of overpowering effects, revealing an accommodation to popularity.

(3) Instead of disclosing perceptions and feelings through wringing new expressive possibilities from the rationalised materials, emotional regression rejects the complexity of adult desires for the simplicity of infantile reactions.

Stravinsky, in other words, finds himself in the fallen condition of modernism, unable to imagine that a return to the Eden of classical harmony is possible. His response is to eliminate lonely individuality and replace it with collectivist conformity, which preserves the modernist sensibility without modern anxiety. Stravinsky's use of folkloric and neo-classical elements in this context appears to Adorno as an aesthetic pastiche lacking any critical dimension, animated by deep nostalgia for a pre-modern community. That strikes Adorno as something with fascist connotations, and he hones in on the formal and substantive features of Stravinsky's work, intent on proving that this is politically concerning and psychologically disturbing.

In Stravinsky's work, Adorno argues, the features of atonal music suggestive of a fresh cage – its polyphonic structure and resulting lack of tonal contrasts; its mathematical exhaustion of a sound space determining a combinatorial aesthetic – dictate reliance on rhythm to introduce variation into the music. In *Petrouchka* (1911) and *The Rite of Spring*, this takes the form of primitive drumbeats that tend to split away from the musical material in the direction of an external envelope, emanating from the primitive past and directing development from the outside.

(Stravinsky) is drawn in that direction where music – in its retarded state, far behind the fully developed bourgeois subject – functions as an element lacking intention, arousing only bodily animation instead of offering meaning… In Schönberg, everything is based on that lonely subjectivity which withdraws into itself… In Stravinsky's case, subjectivity assumes the character of a sacrifice, but – and this is where he sneers at the tradition of humanistic art – the music does not identify with the victim, but rather with the destructive element… Both (*Petrouchka* and *Rite*) have a common nucleus: the anti-humanistic sacrifice to the collective – sacrifice without tragedy, made not in the name of a renewed image of man, but only in the blind affirmation of a situation recognised by the victim. (Adorno, 2007b: 103–7)

Consequently, the music (and the jerking, spasmodic dance that accompanies it) mimes the disintegration of the bourgeois ego into schizoid states, as infantile regression prompted by destructive aggression results not in a return to childhood happiness, but in a state of agonised disturbance. Written between the Warsaw Uprising and the revelations about the Nazi's extermination camps, Adorno is evidently struck by what he describes as a musical image of 'the anti-humanistic sacrifice to the collective – sacrifice without tragedy, made not in the name of a renewed image of man, but only in... blind affirmation' (Adorno, 2007b: 107). In other words, Adorno is frankly appalled at what he thinks anticipates a soundtrack to totalitarianism.

Let us now attempt to summarise Adorno's position by way of a discussion of the significance of the Schönberg/ Stravinsky opposition. Adorno's position on modernism is potentially confusing, because it blends descriptive and evaluative criticism, fact and value, in a way that is characteristic of dialectical philosophy but unusual in Anglo-American art criticism.

• *Descriptively*, Adorno's position on the Schönberg/ Stravinsky opposition flows from his analysis of instrumental reason and commodity reification. Modern rationalisation reduces qualitative, material differences ('the non-identical') to quantitative, ideal similarities ('identity thinking'), generating abstract, formal, quasi-mathematical systems by discarding the substantive part of the natural environment and individual uniqueness. This generates two poles in modern thinking: empty, abstract, formal rationality and a counter-reaction against this, a Romantic desire to directly return to naturalness, substance and uniqueness, in short, 'authenticity', *bypassing reason altogether*. For Adorno, 'authenticity' is mere nostalgia. Rationality and the irrational – that is, rationalisation and

authenticity – have their analogues in the world of art. As ideal types, there is modernist rationalisation and modernist authenticity: one heads in the direction of abstraction and formalism, using methods of construction that emphasise rational technique; the other heads toward the primitive, the infantile, the brutal, rejecting artistic construction for chance encounters and blind expressivity. Of course, in actual artists, these ideal poles on the artistic continuum are often combined – but in Schönberg and Stravinsky, Adorno thinks he has relatively pure specimens that can illustrate his analysis of rationalisation (progress) versus authenticity (nostalgic reaction).

• Prescriptively, although Adorno prefers Schönberg to Stravinsky, rational construction and musical rationalisation to anti-individualistic authenticity and nostalgic pastiche, he is actually not advocating serialism as such. Instead, Adorno would like to see a truly revolutionary 'informal music', or 'free atonality', become a third alternative (Adorno, 2007b: 52), and indeed, he believes that Schönberg is a sort of restoration of order after the brief uprising of free atonality in 1918–23. After the Second World War, in the context of what he called the 'aging of the new music' – that is, serialism's degeneration into sterile formulae – Adorno looked to Karl-Heinz Stockhausen for a new direction. 'An informal music,' he writes, 'would have to take up the challenge of an unrevised, unrestricted freedom' (Adorno, 1998: 275), going beyond the Schönberg/ Stravinsky opposition into uncharted territory. But in *Philosophy of Modern Music*, in the historical absence of any significant 'informal music', Adorno balances the relatively progressive Schönberg against the relatively conservative Stravinsky.

Adorno's position becomes significantly clearer once we translate it from music into painting, for the Schönberg/ Stravinsky opposition echoes the opposition between Kandinsky and Nolde.

Kandinsky and progress

Indeed, in 'The Relationship to the Text', Schönberg announced that his music corresponded exactly to Kandinsky's painting, 'in which the external object is hardly more than a stimulus to improvise in colour and form', liberated from both the external world and from abstract concepts (Schönberg, 2003: 89–90). That might seem confusing, because Kandinsky stands alongside Malevich at the origin of abstraction in modernism, but in actuality it indicates something important about rational construction in music and painting. The abstraction it accomplishes is not an abstraction from particular experiences to universal concepts, but from specific sensations to perceptions in general. In his well-known *Composition VII* (1913) and *Composition VIII* (1923), Kandinsky illustrates what Adorno is advocating in terms of rational construction and spontaneous expressivity.

Composition VII explores the disintegration of the old universe of perceptions and feelings and the rebirth of a new emotional and spiritual universe. Its formal composition consists of a dynamic field of tension that begins from the central eye-like structure and then scatters out along the diagonal running from bottom left to top right, pausing at the circular roundels distributed along the oval envelope of this catastrophe of renewal. The vivid colours establish a depth of field with contrasts of saturation between dun interstitial coloration and the intense hues of the multiple shapes, which hesitate on the threshold between form and formlessness. Reminiscent of a cosmological diagram proceeding from a jagged destructive event at bottom left to the emergence of created entities and stabilising structures at top right, the painting is highly suggestive. Several concepts are alluded to; for example, Kandinsky's drafts for the painting explicitly referred to biblical themes of genesis and apocalypse. Some objects are also implied; for instance, Kandinsky's interest in the splitting of the atom and particle traces in cloud chambers. Yet the painting refuses to coalesce into the field of conventional representational art. It

dialectically negates painterly tradition, cancelling it even while preserving contact with it. (*Composition VII* is, after all, a modernist 'descent of the fallen angels into hell', as the figuration of folkloric demons in the early drafts clearly indicates.)

In *Concerning the Spiritual in Art* (1910), Kandinsky argues that abstraction – a nonobjective and nonrepresentational art of the perceptual and emotional field – is the solution to the crisis in painting generated by the invention of photography. Kandinsky's ideas are not a question of arid formalism, such as the proposition that painting is just about lines and colours on a flat surface. Instead, the exploration of the constructive relations between colour and line (and Kandinsky marries scientific theory to mystical vision on this question) is dedicated to the discovery of a new continent of sensations and feelings. This evolves gradually in Kandinsky's work, beginning from the post-Impressionism of the Blue Rider period. In the lead up to 1910, he aggravates the representation of the act of perception into broad, subjective brushstrokes that break increasingly with the

4. Wassily Kandinsky, *Composition VII* (1913).

stimulus of reality, and complicate it with symbolic elements expressive of unconscious conflicts. At the 'spiritual turning point' in 1910, Kandinsky's turn inwards into specific acts of perception unlocks the possibility of an exploration of perception in general. He made 'Impressions' that recorded the specific act of perception in a style derived from Impressionism. These were followed by 'Improvisations' that reworked the visual material according to principles of the resolution of colours from indefinite hues and their increasing saturation, and the sheering away of lines and shapes from their representational supports. In the 'Compositions', Kandinsky's 'Improvisations' received a secondary revision that aimed at liberating the potential for absolutely unprecedented perceptions and feelings (Kester, 1983: 256). Kandinsky's Compositions are the new sensory apparatus for a fresh world, one that is not yet born. Such an artist is 'perhaps unintentionally a philosopher', who rejects the idea that this is the best of all imaginable situations and instead affirms: 'in its present shape, this is not the only possible world' (Kester, 1983: 255).

Kandinsky anticipates Adorno's dialectics of expressive liberation and constrictive objectivity in his insistence on a permanent revolution in values and feelings that precludes worshipping any fixed form. For Kandinsky, 'obstacles are constantly created from new values that have pushed aside old values', in a process that he describes as 'the effect of internal necessity', where 'the development of art is an ever-advancing expression of the eternal and objective in terms of the historical and subjective' (Kandinsky, 1970: 51). 'It is clear,' he adds, 'that the inner spirit of an art uses the external form of any particular period as a stepping-stone to further development' (Kandinsky, 1970: 51). That Kandinsky understood the human condition and natural environment in terms of a mystical spiritualism in combination with scientific findings – this is what is meant by the 'eternal and objective' – did not prevent him from grasping

the 'historical and subjective' between 1910 and 1923 as a moment of crisis, even dissonance.

The strife of colours, the sense of balance we have lost, tottering principles, unexpected assaults, great questions, apparently useless striving, storm and tempest, broken chains, antitheses and contradictions – these make up *our* harmony…Only the individual parts are essential. Everything else (including the representational element) is secondary. The combination of two colours is a logical outcome of modern conditions. (Kandinsky, 1970: 66)

The Russian Revolution appeared to herald the birth of a new humanity prophesied in *Concerning the Spiritual in Art*, and between 1918 and 1921, Kandinsky worked in Moscow with Lissitsky, before returning to Germany to become a founding member of the Bauhaus movement. If Schönberg dramatises the plight of the autonomous individual in modern society, Kandinsky expresses the hope for a renovated humanity capable of a reconstruction of the sensorium, based on the spiritual exercises outlined in his art theory. The cultural revolution foreseen by Kandinsky was not, however, identical with the increasingly authoritarian process transpiring in Russia, which demanded the reduction of art to an object whose use value was to instruct the masses. Nonetheless, in Russia, the influence of the severe aesthetics of Constructivism pushed Kandinsky's colours and lines away from pastel tones and plastic lines. Upon return to Germany, his art moves toward desaturated hues based on subtractive colours and geometrical abstractions where circles and polygons emerge from the intersections of arcs and lines. Working with the Bauhaus, Kandinsky made the connection between painting the chemical elements of the new world, in increasingly formal reflections on the compositional principles of painting itself, and the revolution of the senses and emotions that this painting aimed at. In the idea of synaesthesia, the crossing over of the senses, Kandinsky moved toward a modernist version of the total work of

art – yet this remained an ideal focus for the renovation of everyday life, rather than an entertainment complex designed to impress. In *Composition VIII* (1923), the riot of pseudo-forms emerging and consolidating in the vortex of perceptual renovation stabilises into a quasi-formal 'language of the eye' that composes semi-representational elements from objective components.

The eye-like structure with emanating rays remains just to the right of centre, now subordinated to the slashing diagonals of sun-like roundels (top left to bottom right) and geometrical chiaroscuro animal-hints toward horse and birds (bottom left to top right). Colour intensity and geometrical vigour push the open triangular mountain-like structures into the background, with the totality creating a recognisable allusion to landscape painting, indeed, to Kandinsky's own celebrated *Blue Mountain* (1908). Yet the representational gestures must be grasped as *projections* outward from the dynamic balance of form and the interplay of cool (blue) and warm (yellow) hues, rather than as abstracted elements from a given stimulus in reality. The ability to recode perception (say, of a landscape viewed under the lens of desire) is an *effect* of the temporary coalescence of two sorts of element: evanescent heating and cooling circular bearers of affective intensities; with, line elements organised through the alternation of symmetrical proportionality with ruptured symmetries. This is not a painting of the mechanised world invading a romantic landscape, for instance, but a painting of the act of subtraction of oneself from the field of conventional perceptions, followed by the reinsertion of the individual back into a transformed reality that trembles on the verge of actualisation.

Nonetheless, just as with Schönberg, during the 1930s an uneasy tension develops in Kandinsky's work between expressive individuation based on rational construction – that is, a new and highly personal 'view' of a potential reality – and the formalism inherent in the preparation of the painterly materials. Kandinsky's work heads into a 'cool', 'mechanical' phase in which the

5. Wassily Kandinsky, *Composition VIII* (1923).

geometrical and tonal abstractions begin to organise themselves with what he calls 'internal necessity', based on their own abstract relations. The law of the preparation of the materials that will compose the field of perception begins to legislate to the field of perception itself, just as mathematics began to usurp serial music and turn it into a game of combinations. By the late 1930s, Kandinsky paints grids in which hieratic forms are arranged, specimens for a future world displayed under dissection within the classifying framework of the rationalising intellect. It is only in the early 1940s that these specimens briefly, joyously, burst the frame, to shimmer in warm, saturated hues and twisting, plastic forms – for instance, in *Sky Blue* (1940) and *Tempered Elan* (1944) – but they flourish in the ocean of the imagination, far from an unredeemed humanity.

Nolde and nostalgic reaction

Things are otherwise with Emil Nolde (1867–1956). Instead of pushing forward through rational construction to the discovery of new perceptions, he gropes backwards away from artistic abstraction for the recovery of archaic feelings. Born Emil Hansen in the town of Nolde near the Danish–German border, he changed his name to bind himself irrevocably to the place of his birth and residence, around the turn of the century. As a young man he experienced what he described as the disintegration of the form of life of Protestant, agricultural Germany and its semi-feudal rural classes, under the blows of industrialisation, commercialisation and modernisation. 'The period from 1871 to the turn of the century,' he writes, 'the foundational epoch (*Gründerzeit*), with its economic boom, was fateful for the more refined old cultural and popular values; they were ignored, squandered, destroyed' (Bronner, 1983: 295 Nolde cited). Nolde's work seeks to recover the union of a pastoral idyll and the cultural past in a modernist form, by breaking with academic realism toward a work composed of evocative, even stark, colours and heavy, spontaneous brush-strokes, whose topics are religious ritual and rural existence.

As Stephen Bronner outlines, Nolde was initially attracted to the Romantic elements in early German Expressionism, and especially to the Munich artists with whose work his own has a strong affinity. Despite a period in Berlin between 1902 and 1912, during which he was uneasily a member of the group *Die Brücke*, the Berlin Secession and the then Blue Rider movement around Kandinsky, Nolde felt that these movements threatened his individuality with their strict artistic discipline and tendency toward abstraction. His belief was that German art must have nothing to do with effeminate French Impressionism, with its reflexive investigation of light and tonality, but must instead drive in the direction of an expression of the ground of experience that he felt lay in the original unity of nature and humanity. Not surprisingly, given his technical preferences, Nolde considered

van Gogh to be a fortunate exception to the rule that civilisation means loss of contact with authentic existence. But where van Gogh was struck by the solidity of the natural world, Nolde sought the psycho-spiritual essence that animates it, something that shunted his work away from strictly representational forms toward vibrant allegories, where human and natural shapes only just emerge from the energy of the brush-work. In the archaic core of civilised men and women he discovered

the place in a man where the most varied qualities, raised to their highest powers, harmoniously unite. (This is the) ground upon which the greatest art can blossom forth: at once natural man and a man of culture, simultaneously divine and animal, a child and a giant, naïve and sophisticated, full of feeling and full of intellect, passionate and dispassionate, gushing life and silent calm. (Bronner, 1983: 296 Nolde cited)

For Nolde, spontaneous naturalness and archaic ritual are one. His well-known *Bedevilled Dancing* (1909), where joyous children dance wildly in a group, belongs together with *Dance around the Golden Calf* (1910), both in terms of form and content.

The cavorting women, with the pagan idol of the Golden Calf that so incensed Moses in the background (*Exodus* 34:4), are captured in a moment of ecstatic communion in the midst of expressive movements of joy. Their motion, preserved by long, smooth outlining brushstrokes, particularly around the legs of the black woman, is heightened by dry-brushing that looks like (but is not) remnant sketch outlines around the legs of the two framing figures. The whole artfully gives the impression of rapid, excited work that must move quickly in order to delineate the main contours of this wild jubilation. Although some of the women vaguely echo in their golden and tan tones the object of their veneration, they remain differentiated, not by facial features (which are de-individualised and gestural), but by differences in skin pigment and hair colour. The palette is earth-toned but strongly distinct, ranging from scarlet hair of the woman on the

left to the purplish-brown of the central figure and the strong contrast between white ground with blue shadows, and the sunny golden tones that foreground the dancers. The entirety strives for an artless naturalness of form as well as content, based on large, thick strokes performed as if in haste, with the artist's technical abilities carefully concealed behind secondary revisions designed to look like elements of incompletion (sketch remnants, blocked forms, refusal of elaborate shading, pastel palette without much tonal graduation).

As Bronner notes, Nolde's vision is inclusive at the same time as it is atavistic (Bronner, 1983: 301). His interest in dancing children, the 'primitive races' of non-European countries, the ancient Jews and his rural compatriots, springs from the same

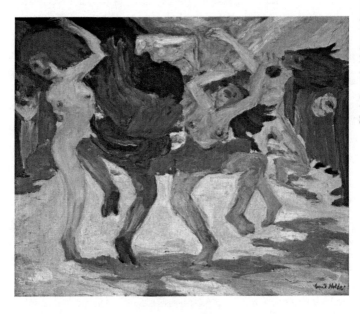

6. Emil Nolde, *Tanz um das Goldene Kalb* (1910).

soil. 'Primitive people,' he writes, 'live in their nature: they are one with it and part of the entire universe. I sometimes have the feeling that only they are the real people, while we are something like deformed marionettes, artificial and full of presumption' (Bronner, 1983: 300 Nolde cited). His interpretation of Exodus reinforces this, transforming what Moses regarded as the Israelites' religious transgression into a spontaneous expression of worship of nature. Maintaining a belief in 'the religion above religions', Nolde held that the true root of Protestant piety was not the severely civilising influence of Jewish monotheism, but the ecstatic ritual of communal celebration. What that means is that Nolde's interest in history and geography is not an interest in the historical possibilities for full individuation or the variability of human culture. Instead, it represents the recruitment of other times and places to a monolithic vision of spiritual regeneration, won through sloughing off the contamination of industrial civilisation and reflexive religion. Consistent with this vision, the dancing women and children of 1909–10 are types (the Israelite of African descent, the red-headed Jewess...) rather than *individuals*.

The topic of Nolde's painting perhaps inspired Kandinsky's discussion of the painter as a modern Moses descending on the idolatrous Israelites with a new wisdom (Kandinsky, 1970: 29). But Nolde's return to the ground of experience means surrender of individuality; contact with the vital essence of human existence means renunciation of historical possibilities for social freedom; striving for authenticity and naturalness entails endorsement of ideological stereotypes (woman as nature, the African as nature, the child as unspoilt nature, etc.) (Bronner, 1983: 305). That Nolde was a charter member of the North Schleswig division of Hitler's National Socialist Party (Bronner, 1983: 293) corroborates the idea that the aesthetics of authenticity is connected to the politics of reaction. His work is animated by rage against decadence (which in his mind is coextensive with rationalisation) and hatred of city

intellectuals. Authenticity means an artful aesthetic regression, supported by all of the clichés of the ideology of feminine nature versus masculine culture, something that leads Nolde to alternately exalt peasant and denigrate urban women. He was genuinely surprised when the Nazis in power suppressed his work as degenerate art (Selz, 1974: 124). From the 1930s onwards until his death, he painted landscapes of great expressive power: in this case, the elimination of the human dimension did not correspond to extermination, but to an 'inner emigration' out of Germany, history and modernity (Bronner, 1983: 307).

Chapter 3

Aesthetic theory

Adorno's posthumously published *Aesthetic Theory* (1970) is his most important statement in defence of the autonomous artworks of the modernist movement and, specifically, in support of the dissonant aesthetics of postwar modernism. In it, he provides a full explanation of why he connects artistic breakthroughs by means of rational construction with the politically radical struggle for individuation against the administered society. According to Adorno, there is an interconnected sequence of contradictions that constitutes modernist artworks, beginning from the location of art in the social division of labour and ascending to what he calls 'political migration', the shift of radical politics away from mass movements and into experimental art. In this chapter, I explore the most important of these dialectical oppositions, between material and technique, and content and form, in the context of the idea of postwar modernism as both aesthetically progressive and politically emancipatory.

Aesthetic Theory is the theoretical statement on art that was intended to belong together with Adorno's exploration of philosophy in *Negative Dialectics*, just as *Philosophy of Modern Music* represented the companion piece to *Dialectic of Enlightenment*. Yet although Adorno completed the text, his final revision was interrupted by death; as a result, the work is often repetitive and sometimes opaque, and its sequence of exposition remains something of a secret. Fortunately, Lambert Zuidervaart,

in *Adorno's Aesthetic Theory: The Redemption of Illusion* (1991) has provided a masterful reconstruction of its logic, while Shierry Weber Nicholsen, in *Exact Imagination, Late Work: On Adorno's Aesthetics* (1997) offers a thoughtful exploration of 'mimesis' in Adorno. I have relied extensively on Zuidervaart in this chapter but, following the hint from Nicholsen, intend to stage this in the context of an encounter with a major artwork (Zuidervaart, 1991; Weber Nicholsen, 1997).

My intention is to confront Adorno's *Aesthetic Theory* with the Neo-Expressionist work of Anselm Kiefer, whose works stage a provocative retrieval of representational art – indeed, of landscape painting! – after Conceptual Art. The choice of a painter-sculptor whose work returns to figuration is a motivated decision, because I wish to address two common, related misreadings of Adorno's position:

- Adorno's aesthetics is often understood as involving a meditation on art after Auschwitz that amounts to a 'ban on images', precluding any retrieval of figuration. Benjamin Buchloh, surely the most brilliant of all of the Adorno-inspired art critics, goes down this road in *Neo-Avantgarde and Culture Industry* (2001). According to such a representation, Beckett marks the final moment in which instrumental reason totally dominates the postwar world. The equivalent development in the visual arts is Abstract Expressionism. After the canvas of Abstract Expressionism shrivels to the black monochrome, with Mark Rothko's final paintings, the only possible protest is the exhibition of reified objects as art, in a mute statement of the impossibility of individuality in the administered society. From the 1960s onwards, sculpture and painting converge in forms of Conceptual Art that use found commodity objects and reproductions of commercial art to execute a subversion of late capitalist culture that

is performed with a blank face. Andy Warhol, Roy Lichtenstein, Hans Haacke and Buchloh's favourite, Marcel Broodthaers (Buchloh, 2001: 65–118), are placemarkers for these sorts of aesthetic practice. Meanwhile, the autonomous subject signifies that its existence is on life support with an almost imperceptible wink, in the form of a last expressive gesture – the finding and placement of an object, a defacement or signature on a blank canvas or an artistic copy, and so forth.

• In connection with this supposed vision of the extinction of the expressive subject, Adorno's work is often misunderstood as entailing an 'end of representation' hypothesis. In Hegel's aesthetics, the historical teleology of advancing freedom is reflected in the progress of art from figuration to abstraction, culminating in the moment when, with the achievement of a free society, art ceases to exist and passes over into philosophy. Adorno's book was to have been dedicated to his friend, Samuel Beckett, whose literary works, when readers overlook their hilarious aspect, appear to be drama about the impossibility of theatre and novels about the exhaustion of literature. Interpreters of Adorno who propose the 'extinction of expression' position generally seize on this and suppose that he inverts Hegel into a historical teleology of advancing domination. At the same time, they retain an upside-down version of Hegel's 'end of art' position, as a thesis on art's impossibility in connection with the disappearance of the subject. From this perspective, Conceptual Art is really the only legitimate form today, because this can be interpreted as a statement on the crisis of modern art, in which art questions its own right to exist. In 'Figures of Authority, Ciphers of Regression: Notes on the Return of Representation in European Painting', Buchloh runs this line. He engages exclusively with catalogue descriptions rather than with actual works,

to propose that Kiefer is involved in artistic regression that can only bring in its wake the rehabilitation of authoritarianism (Buchloh, 1981: 65).

Throughout this book, I have argued that this sort of grim perspective neglects the way in which Adorno's dialectic is *divergent*, not convergent, as well as the way his aesthetics suggests that every breakthrough opens new expressive possibilities, even if these tend to close up over time. According to Adorno, the expressive subject cannot be eliminated, because it is itself a residue of nature caught in the rational machine, and the resulting impossibility of the individual's complete adaptation to society means a permanent potential for resistance. There is a 'ban on images' in Adorno, but it is not the proscription of figuration – rather, it is a prohibition on the direct representation of reconciliation (Buck-Morss, 1977: 24). Indeed, *Aesthetic Theory* stages, amongst other things, a provocative rehabilitation of the category of beauty, including natural beauty, which is something that sits uneasily with the supposition that Adorno is all about the colour black. Adorno insists that art must inhabit a field of contradictions constituted by the tension between critical negativity and utopian anticipation. Consequently, Adorno's aesthetics is all about the eruption of the principle of hope through an art that is highly self-reflexive about its own historical position, rather than the reduction of art to an arid conceptuality that would be better handled by means of logical propositions. Finally, Adorno's aesthetics is completely historical, alert to the shifting relation between the individual and society, rather than trying to legislate a final form to artworks. Autonomous art is 'nourished by the idea of humanity':

(It) can no more be reduced to the general formula of consolation than to its opposite. The concept of art is located in a historically changing constellation of elements; it refuses definition…Art can be understood by its laws of movement, not according to any set of

invariants…It is outside the purview of aesthetics today whether it is to become art's necrology; yet it must not play at delivering graveside sermons, certifying the end, savouring the past, and abdicating in favour of one sort of barbarism that is no better than the culture that has earned barbarism as a recompense for its own monstrosity. (Adorno, 1984: 1–4)

Unlike his mentor, Joseph Beuys, who refused to face up to history, Kiefer's popularity with Jewish art collectors springs from his lacerating confrontation with historical memory in postwar Germany (Saltzman, 1999: 121). Kiefer's immensely expressive work certainly exhibits a contradiction between fragile and perishable natural objects, such as poppy seeds and chickpeas, and the artificial materials of industrial civilisation, such as metal plates, barbed wire and coagulated oil paints mixed with ash and then deliberately burnt with a blow-torch. By contrast with Beuys, however, these are not deployed in the service of theosophically derived, Romantic speculations on an unspoilt and authentic nature that needs to be experienced in its 'being-there' in order to reconnect with a pre-rational goodness. Instead, rational construction in Kiefer takes the form of a provocative meditation on art history, and especially, on the history of art as a vehicle for teleological narratives and mythic constructions that have real historical effects, whether for liberation (especially Jewish mysticism) or domination (especially Germanic folklore).

Art after Auschwitz

The reader might protest that Kiefer (1945–) is not an appropriate object of analysis because his art really begins in 1969, the year of Adorno's death. Some of Kiefer's most important works are from the 1980s and 1990s, in the context of German reunification and Kiefer's own response, emigration to France. Adorno could not, therefore, have been talking about the sort of post-conceptual revival of figuration that Kiefer, and other Neo-Expressionists, are

performing. But in actual fact, Adorno is right up-to-date, partly because German postwar culture is characterised by belatedness. Inspired by the methods of the Frankfurt School, Alexander and Margarete Mitscherlich proposed in *Inability to Mourn* [1969] that the two decades following World War Two in Germany had been characterised by a melancholic blockage on historical memory. German art and culture during the 'postwar miracle' of national reconstruction produced a sort of 'ban on images' of recent history, emblematised by a resolute focus on the present and an equally resolute refusal to examine the past. At its root, they argued, lay the loss of a beloved image of authority that nobody could acknowledge ever having loved – Adolf Hitler – with the consequence that attitudes to German nationalism amongst the generation born around the time of the war were highly ambivalent and mostly unconscious (Mitscherlich and Mitscherlich, 1975: 25–26, 45–46).

It was not until the 1970s that German culture began to really work through the implications of the past, although, as Kiefer notes, there was something inconclusive about this, for 'in Germany, not a single magistrate [who worked under the Nazis] was indicted – there was no [full] re-examination' (Celant, 2007: 472 Kiefer cited). Indeed, the Mitscherlichs may have underestimated just how true their theses were, for *as late as 1986* in the 'historians' dispute', conservative members of this generation, now in positions of considerable authority, proposed to recover the German cultural heritage 'without guilt' and reconstruct a 'useable image' of Germany's past. What this meant, as Adorno's former student and current successor in the Frankfurt School, Jürgen Habermas, immediately pointed out, was wholesale repression of the ways in which the idea of a distinctive 'Germanness', from the Enlightenment onwards, made fascism possible. Such an approach implies a sanitised historical narrative that would transform Hitlerism into a sort of unfortunate accident (Habermas, 1989).

As the perceptive Adorno-influenced critic Andreas Huyssen notes, Kiefer's work happens in a particular zone within this context. It is an intervention not within German culture as a whole, but within the anti-fascist, liberal intellectual culture that arose in the 1970s (Huyssen, 1989). Despite their insistence on working through the historical part, German progressives maintained a specific repression of their own, namely, a taboo on fascist aesthetics (which include an eclectic combination of monumental neo-classicism with mythic elements from the 'Germanic heritage'). In Germany, the Left imposed a ban on figuration as means to repress fascist aesthetics, and this prevented an engagement with art history itself. The extraordinary enthusiasm in postwar Germany for the nonrepresentational forms of Abstract Expressionism, Minimalist Art and Conceptual Art, are *symptoms* of this blockage. As Huyssen puts it, Kiefer:

took aim at the deliberate and conscious repression of fascist themes and icons on which the left-liberal consensus of *Vergangenheitsbewältigung* (working through the past) was built, and insisted that Nazi culture's exploitation and abuse of traditional German image worlds had to be worked through as well. (Huyssen, 1992: 88)

Kiefer proposes that lack of engagement simply means that the aestheticised myths remain unmastered, returning in the dark form of renewed nationalism around reunification. He also refuses to accept that twelve years can ruin painterly techniques developed since the Renaissance or myths thousands of years old, as if the Nazis – of all people! – were competent judges of the meaning of these things (Celant, 2007: 472). Kiefer insists that everything that fascism presented as univocal, he makes ambivalent, wresting meaning-potential away from totalitarianism by engaging with art's insertion in the history of the state and society (Celant, 2007: 406–8).

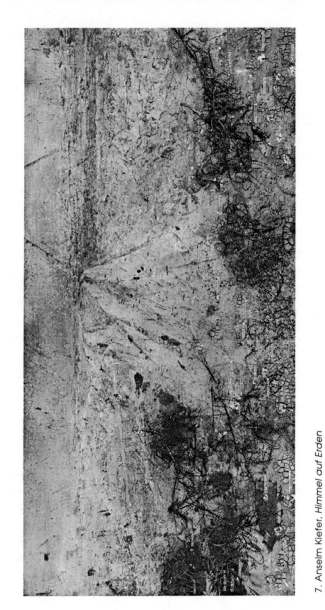

7. Anselm Kiefer, *Himmel auf Erden* (1998–2004).

For Kiefer, who insists that he is 'not a painter', just an 'artist from Germany' (Celant, 2007: 295), then, new expressive possibilities can only be won through a confrontation with the ways that the dark by-products of reification are specifically disclosed in German history and deposited in the aesthetic materials themselves. An analysis of commodity culture and state bureaucracy, in line with the neo-avantgarde, is simply not sufficient. There is no doubt that this confrontation is lacerating, as a glance at *Himmel auf Erden* [*Heaven on Earth*, Figure 7] (1998–2004) demonstrates.

The painting is monumental in scale (5600cm x 2800cm), designed to dwarf the viewer and overwhelm perception. Its texture, which is several centimetres deep, is achieved using layers of oil and acrylic mixed with mud and ash, fixed with shellac, and combined with lead, taken from the Cologne cathedral dome, which has been oxidised by incendiary chemicals. The 'starscape/landscape' has then been set on fire by being burnt in places with a blow torch, exposing levels of cracking, dried material with a tendency to fall off the surface. Rusted razor wire of the sort used exclusively to contain human beings extrudes from the surface in a crude arc, barring entry from foreground into the background along a stretch of lighter, smoother texture that is strongly reminiscent of an improvised road. Although the overall colouration is a dun brown deepened with ashen gray, studded into the surface are informal roseate shapes of pink and white, with black cores, each labelled with an alphanumeric sequence inscribed on a white platelet. Although it is perhaps difficult to see in the reproduction (above), there is something interesting about this. Because of scale, the asymptotic convergence of the road tracks dominates perception. This situates the painting in the representational space of one-point linear perspective, turning the upper fifth of the work into a deserted sky apparently streaked with ash and blood. But actually, the geometrical recession in the proportions of the identifying plaques is organised by something different. This is most probably a complicated curvilinear

perspective, such as a curvilinear barrel distortion with perspectival foreshortening, of the sort used to represent the night sky on a two-dimensional surface.

At first glance, the painting belongs to Kiefer's most desolate sequence of landscapes, depicting the mystified spaces and deserted battlefields of Hitler's *Grossdeutschland* (Greater Germany), exemplified by Prussian claims on most of Poland. With the ash of catastrophe sewn into the sickly grey earth, the roads suggest heavy vehicle movement beyond a wire detention point designed to prevent civilian passage, representing the space of invasion transpiring under a ruinous skyline. Many of Kiefer's works resemble this basic distribution of elements, with explicit references to concentration camps, and to demented aggression in a burning world that is choked with coagulated ash and dominated by the mythical iconography of totalitarian power. In other words, they literalise the aggression implicit in those pastoral depictions of the natural soil of the 'German Fatherland' that go right back to the time of Goethe: as Kiefer says, 'you cannot have an innocent representation of a landscape' (Celant, 2007: 295). There is no evading a series of connections to others of Kiefer's paintings, too, which deepen the association with calamity while broadening its connotations beyond the specifically German reference. The alphanumeric labels connote the identification numbers allocated to the inmates of detention camps the world over. The generality of that allusion is made possible because the platelets identify flowers, which references, amongst other things, the *Let a Thousand Flowers Bloom* sequence, examining Mao-Tse Tung's totalitarianism. In those works, under the sign of melancholia, Kiefer repopulates with flowers the spaces emptied by extermination and conquest, memorialising the victims rather than celebrating the potentates. Adorno's co-thinker, Walter Benjamin once wrote that high culture is the product of historical barbarism, meaning that great art is produced within a division of labour shaped by imperialist

conquest and brutal suppression. *Heaven on Earth* echoes this idea, with the flower-like objects assigned identifying labels in a landscape that brings together Mao and Hitler into a global, authoritarian complex.

Upon closer inspection, however, a second set of meanings is released from the work, in direct opposition to the first set. For instance, the identifying alphanumeric sequences have the characteristic form of NASA star designations. Yet although the 'flowers' are labelled as stars, this does not prevent stars from also acting as concentration camp inmates, as Kiefer's *Sternen Lager IV (Star Camp)* (1998), a detention centre hallway stacked to the rafters with boxed stars, demonstrates. Heaven on earth is therefore *literalised* in a fall of the astral bodies from the sky into the scorched terrain, in a simultaneous warning never again to attempt to directly incarnate a mythical cosmology on earth, and a sign of regeneration emerging, fragile as a flower, from the ruined earth of recent history. Fascinated with the arbitrary nature of the constellations, Kiefer connects this with the ability of human beings to invent meanings and make connections that can be destructive or creative, according to inclination. For the flower-stars are, without question, *also* individual souls, as *The Secret Life of Plants* (2001), with its connections between census forms, astronomical diagrams and alchemical correspondences between flowers and stars, indicates. The promise of heaven is *already on earth* in the spiritual qualities of human beings, arising from the burnt ground of historical memory in a promise of redemption. But the barbed wire remains foregrounded, defying any premature reconciliation.

In other words, Kiefer builds up a symbolic universe in the context of his engagement with alchemical ideas and Jewish mystical spiritual practices, especially Merkabah and Kabbalah. His works operate as ambivalent words in a private language, building up meanings through a process of accumulating connotation rather than logical clarification. This reflects a

process of the retrieval of the spirituality of the oppressed against the mythologies of the dominant. Rejecting Neo-Platonic dualisms of matter and spirit, Kiefer insists on a spiritualism of material bodies, where the spiritual light of individuals arises through their earthy substance, not in opposition to it. Nonetheless, Kiefer's interest in the mythic world does not issue in the Romantic sublime or an apocalyptic irrationality, for it is driven by modern scepticism as well as by spiritual exploration (Celant, 2007: 336). Rather, it leads to a recovery of what lies on the underside of the culture-barbarism connection, *as the underside*, in an appeal to a '[virtual] reunification, which will never happen...the two halves of a picture that will never again be one, because those who were on the other side of it have been murdered' (Celant, 2007: 203 Kiefer cited).

Creative praxis and artistic 'monads'

Kiefer's works are 'hermetic' in the fullest sense of both meanings of the word. They are sealed containers that resist entry and they are a form of secret writing accessible only to initiates. Indicative of the first meaning, Kiefer's works have often been completely misunderstood in Germany and denounced as an irresponsible revival of fascist aesthetics. Illustrating the second meaning, Kiefer's art only releases its significance in the context of knowledge of his overall production (that is, acquaintance with his private language), and, especially, an understanding of his sceptical engagement with mystical spirituality.

Adorno is well aware of the hermetic quality of modernist artworks. He locates them as autonomous fragments drifting in a sea of universal equivalence, and characterises their paradoxical nature in terms of a description of modernist artworks as social 'monads' (Adorno, 1984: 322). The 'monad' is a metaphysical concept from the history of philosophy whose meaning combines the idea of a 'windowless room' with that of a 'fundamental element', or basic qualitative property existing

in the world. Now, that can seem a most confusing expression, because the original 'monadology' is a highly speculative work in metaphysics by Gottfried Leibniz (1646–1714). Leibniz claims that a monad is a unitary substance, perfectly unaffected by the world around it. Yet at the same time that Leibniz contends that the monad is like a room with no windows, Leibniz also maintains that the universe is the sum of all of the monads (substances), marvellously arranged by God into a harmonious totality. Indeed, the sensible world is nothing but the combination of monadic substances into compound materials. These metaphysical atoms are so arranged, Leibniz asserts, because the laws of the totality determine the formation of the different monads, and, indeed, different monads are but the expression of a specific state of the law of the totality (just like different notes are harmonic states of the vibrations of a single string). The consequence is that the monads are both completely enclosed, and contain, because of the law that generates them, the macrocosm in their microcosm.

Strange as it is, Adorno finds this idea immensely suggestive. The *meaning* of the artwork's autonomy is that it self-legislates; that is, that it absorbs social and natural raw materials into its substance and converts them into artistic content, under the law of its form (Adorno, 1984: 4–5). It is thus enclosed – windowless. Indeed, modernist artworks hermetically shut society out. Yet this very act of self-formation, the self-legislation of the artwork, is but a local state of the social totality, for artworks are generated within the division of social labour by a particular kind of practice. In the end, they take their place alongside all of the other commodities produced within the division of labour, even though, in keeping with their specific location in the social totality, they are a paradoxical kind of commodity. It is crucial to realise that, for Adorno, this stamps autonomous artworks with the social contradictions of capitalist society, irrespective of authorship and theme. Artworks are thus those microcosms

(aesthetic universes) that express the contradictions of the macrocosm (the social totality).

A glance at Marx can clarify Adorno's intellectual strategy here and explain the stakes in his description of modernist artworks as monads. Marx begins his analysis of capitalism by stating that 'capitalist society presents itself as an immense accumulation of commodities', and then goes on to note that the commodity 'is a mysterious thing, full of metaphysical subtleties and theological niceties' (Marx, 1963: 71). This is a world made up of windowless rooms (commodities) that are hermetic, because the 'hieroglyph of value', the law that connects them all, has not yet been 'deciphered' (Marx, 1963: 72). The key to the totality, Marx maintains, is a special sort of commodity that contains in its fundamental properties the basic contradiction regulating the relation of parts to whole and individual to society. This special commodity is the worker's labour-power, or ability to labour. Labour-power is commodified, because the worker hires out their own capacity to perform skilled work in exchange for a wage, which is just the monetary form of the commodities that the worker needs to sustain themselves. But the worker's labour-power is also *not* a commodity, because although it is exchanged on the market, it is not produced specifically for sale, but is a natural property of the worker themselves as a human being. This opens up a series of contradictions, between human creativity and alienated labour, use value and exchange value, abstract and concrete labour in the workplace, productive forces and social relations in society, and so forth, that reveal the secret of capitalist production to be the exploitation of the working class. In a strange way, then, as Lukács points out, the revolutionary consciousness of the socialist proletariat is actually the 'self-consciousness of the commodity', the self-awareness of a special commodity (labour-power) that exploitation is the historical truth of capitalist society (Lukács, 1971: 199).

Adorno believes that the proletariat today risks integration into consumerism. But he has not given up on Marx's *style* of

analysis. He positions art in a revolutionary role at the heart of the contradictions of capitalism. For Adorno, although autonomous art is commodified, unlike the standardised commercial products of the culture industry, it is not structured as a useful item. It is produced to express individuality, generally speaking in opposition to commodification and out of indifference toward commercial success. Accessibility, and therefore saleability, is not an important consideration. Hence the autonomous artwork is hermetic, because this sort of practice is quite literally unintelligible in a market society. Unlike alienated labour performed through instrumental rationality in the normal workplace, the formation of the artwork requires human creativity, what Adorno calls 'creative praxis', for its realisation. That is not because artists are special people (creative geniuses, for instance), but because the artwork is useless, whereas all of the other commodities are useful. Creative praxis, for Adorno, means the transformation of nature into impractical things – pure play – whereas social labour means the transformation of nature into practical items intended for commercial exchange. But a truly human existence is playful reconciliation to the natural environment, not instrumental manipulation of raw materials. The autonomous artwork is therefore a special commodity – it is the commodity that expresses the self-consciousness of social labour, the last reservoir of creative praxis in an alienated world (Adorno, 1984: 246–49). As Zuidervaart states, 'in the apparent absence of a revolutionary proletariat and a critical public, Adorno's philosophy is driven to discover how spontaneity in authentic modern art can encourage transformative praxis' (Zuidervaart, 1991: 108).

'Artworks are,' says Adorno, 'the plenipotentiaries of things that are no longer distorted by exchange, profit, and the false needs of a degraded humanity' (Adorno, 1984: 227). In an almost totally reified society, autonomous art has become the last refuge of that creative praxis which points beyond alienated labour. It is therefore also the final retreat of the expressive subject under

conditions where full individuality cannot be achieved in society. Yet despite the transformative potential of autonomous art, were modernism to attempt to directly exhibit a world characterised by non-alienated human creativity, this would lead immediately to falsification. This is not only because artistic practices continue to be part of the social division of labour, but also because the society itself has not yet been transformed from a state of unfreedom to a condition of freedom. Art therefore has what Adorno calls a 'double character', as both autonomous structure and social phenomenon – it is 'both more and less than praxis' (Adorno, 1984: 241, 248). Autonomous art is at once a form of creative praxis that is the antithesis of social reification, and something powerless to alter the mutilated practices enmeshed in the social division of alienated labour. Radical artworks must therefore remain true to the contradiction that constitutes them, by simultaneously both preserving and negating the artistic promise of human happiness. Adorno thinks that the only way that this can happen is through aesthetic dissonance.

Autonomous art, by its existence, protests against reification and rationalisation. Autonomous art is the antithesis of instrumental rationality and commodity reification, and of the social division of labour that generates these problems. Its combination of human creativity with a labour process potentially resists routinisation and domination. Its combination of mental with manual labour is the opposite of the mutilating separation of these forms of activity in the social division of labour. Accordingly, art is the antithesis of society because it represents the possibility of creative praxis, something that inherently anticipates utopian reconciliation (Adorno, 1984: 8). In agreement with Kant's idea of art as 'deliberate uselessness', Adorno maintains that 'insofar as a social function can be predicated for artworks, it is their functionlessness' (Adorno, 1984: 227). Indeed, under conditions where intellectual culture has been included in the division of labour and industrialised,

with results of standardisation and homogenisation, the independence and individuality of the artwork is an act of defiance. 'Art keeps itself alive through its force of resistance,' Adorno suggests, which springs from its combination of social dysfunctionality and aesthetic autonomy (Adorno, 1984: 226).

Despite its exceptional role, however, art is also part of the social division of labour. Artworks are commodities that are generally fetishised as 'high art' and supposed to belong to an elevated 'spiritual culture' entirely distinct from material existence. But in actuality, artworks are riven by internal contradictions that express the antagonistic character of social relations in capitalist society. The main connection between the autonomous artwork and social contradictions is the social labour of artistic production, especially the dialectic of aesthetic material and artistic technique, which we will examine in a moment. These contradictions render even autonomous artworks inconsistent and divided, fragmented and problematic. Yet autonomous artworks strive to conceal the social labour of their manufacture by means of their own internal consistency, their drive toward being independent, self-legislating entities. This leads to their possession of a quasi-magical aura that is an ideological illusion, something which serves to render enigmatic the historical contradictions congealed in their materials and structure.

Material and technique

We have seen that Adorno regards the modernist artwork as a social monad formed within the division of labour, and that this involves a contradiction between creative praxis and alienated labour. He locates the artwork at the intersection of social forces operating in the world of aesthetics, which generate the work as a field of tension. The most important one is between the historical state of the aesthetic materials and the artistic technique of the work, and Adorno thinks of this in Marxist terms as a contradiction between artistic productive forces

(materials) and social relations of production (technique) (Zuidevaart 1991: 101–2). Indeed, according to Gillian Rose, 'the central thesis of his sociology of art is that there is a contradiction between the forces and the relations of production in the realm of culture' (Rose, 1978: 119).

Now, for Marx, the productive forces and social relations are located in the economic foundations of society, as a contradiction between technological development and property forms. Marx thinks that advances in technology are enabled by developments in property forms, but then eventually burst apart the restrictions of these property relations. Accordingly, Marx believes that capitalist forms of private property stimulated the industrial revolution, but that subsequent technological progress within capitalist society has prepared the ground for socialist revolutions that will abolish private property and replace it with the higher form of socialised property. Although Adorno has major reservations about Marx's ultimate vision, he nonetheless thinks that just such a historical dialectic applies in the arts, where increasing rationalisation of aesthetic materials has burst apart the conventional techniques that produce the organic totalities of bourgeois realism, mandating modernist techniques. Indeed, Adorno holds that this dialectic between aesthetic materials and artistic techniques is constantly active in the period of modernism, in the historical dialectic that we explored in the last chapter.

Adorno therefore has a demanding conception of artistic progress that depends upon the idea of artistic breakthroughs defining the level of advance of the aesthetic materials. For Adorno, technique involves the mastery of these advanced materials, and can be defined as 'all the artistic procedures that form the material and allow themselves to be guided by it' (Adorno, 1984: 213). As the latter part of that definition suggests, the concept of technique is complex, because Adorno thinks that technique is not entirely external to the material, but arises from a confrontation with the expressive possibilities latent in it.

Specifically, technique is a determinate negation of the material, which means, colloquially, it is a set of historically conditioned procedures for doing something different with the material. Most importantly, technique is a response to the objective problem that advanced material poses. Nonetheless, Adorno acknowledges that there is no global unity to the history of modern art, only developmental sequences along certain lines (Adorno, 1984: 209). In *Philosophy of Modern Music* Adorno believed it was legitimate to speak of a work as exhibiting the 'single' technically 'correct solution' to an expressive problematic defining an entire medium (Adorno, 2007b: 26). In *Aesthetic Theory*, Adorno qualifies this by stating that a certain sequence of development poses objective problems, but that these remain localised within one of several approaches to a medium (Adorno, 1984: 209–10).

In relation to Kiefer's art practice, the materials consist of the physical substances (oils, acrylics, ash, shellac, natural objects, barbed wire and lead plates and so forth), together with the historically developed rules for their application in the field of landscape painting (e.g., linear perspective, representational conventions, guidelines for the selection of appropriate scenes). Kiefer's materials also consist in the symbols of various mythic cosmologies, together with the historically developed conventions of their application, and the original models for his works, which are not physical places but pre-existing representations of those places, especially ones appropriated by fascism. The preparation of the materials consists of their ruination through distressing (crumpling, bending, corroding), followed by their resurrection through alchemical purification treatment that bleaches sections of the lead to white and burns ash into fired paint. As well as a symbolic purgation that leaves visible traces in the work, this represents a dialogue with radical experimentation in testing the limits of the objects that constitute art, from Duchamp onwards. Kiefer's breakthrough consists of the *redemption of materials* after these had seemed exhausted, precisely through their

historicisation (aging through distressing, renovation through purification). His intervention happens at the moment where Conceptual Art seemed to have demonstrated that art must abandon figuration altogether for a concrete presentation of ideas. What Kiefer demonstrates is that figural forms in painting (and sculptural volumes) can continue to resonate, provided that they make their own historicisation an explicit theme. But, as we have seen with the distinction between Schönberg's atonal compositions and the formalistic procedures of his followers (e.g., Webern), artistic breakthrough is not just a question of the preparation of historical materials in a novel way. The materials must be handled artistically, through a compositional or constructive technique.

The question posed by Kiefer's materials is clear enough, at least in relation to his specifically German themes: how to make the monomyth of the state into something ambivalent and historical, without unintentionally retrieving a viable neo-fascist aesthetic? Expression must be wrung from Kiefer's alchemically resurrected materials by a technique of combinations that activates subordinate potentials in them, as with the visual confusion of star designations/intern identifications, thus restoring ambivalence and complexity to them. We might describe this as a technique of contrary combinations, through which Kiefer achieves a dense layering of mythic allusion and symbolic reference. This prevents his works from becoming either merely anti-Nazi allegories, or regressions to fascist aesthetics.

Nonetheless, Kiefer's technique is extraordinarily risky, because it involves a rehabilitation of the category of the beautiful in the context of mythic symbols compromised by history. This is the opposite of postmodern techniques of pastiche and collage, which invoke the sublime in their tendency to generate an infinite regress of reference, from 'text' to 'inter-text'. The risk is that the figural dimension of Kiefer's artworks, with their evident striving for aesthetic unity and identifiable reference, will become merely decorative because they stand in jeopardy of an

all-too-easy decipherment. Of course, a decorative statement about fascist aesthetics is no protest at all, but an inadvertent surrender to the very thing the artist intended to oppose. This risky technique is a calculated strategy, which makes it the opposite of the mystified methods of someone like Beuys:

Kiefer is not a latter-day shaman whose use of materials and performance strategies comes out of an existential experience and gains its utopian healing power within that framework. Kiefer works more like a secular *bricoleur*, with a gargantuan appetite for mythic stories and references, it is true, but also with an acute consciousness of loss and insight into the impossibility of attaining some ultimate reconciliation. Beuys's fat and felt can be read to embody an emphatic vision of healing and nurturing. Kiefer's lead, by contrast, remains fundamentally ambivalent: it may turn into the alchemist's gold, but it is poisonous. It protects against radiation, but it absorbs all light. It is gray, dead matter, but begins to shine when subjected to processes of erosion and oxidation. It is associated with Saturn, the least-lit planet in our solar system, with darkness, black gall, and melancholy, but then melancholy has often been considered central to the artistic imagination, and it certainly has been a prevalent element in the psyche of the post-Auschwitz generation in Germany. For Kiefer myth itself is neither some primary reality nor guarantee of an unquestioned origin. It is rather an attempt to construct meaning and reality via storytelling in images. (Huyssen, 1992: 92)

Content and form

According to Adorno, the dialectic of material and technique gives rise to the dialectic of content and form. The historical material confronts the modernist artist as an ensemble of exhausted genres, conventions and devices. Only radical technical innovation can accomplish a renovation of the historical material, and this is deposited in the work as decisively new content. Yet the content, which arises from artistic mimesis – that is, the effort to imitate something in the world – must be aesthetically formed, and this is crucial,

because form differentiates art from potentially useful things. 'Art,' Adorno maintains, 'is [only] released from the empirical world by its formal consistency' (Adorno, 1984: 138). If mimesis is spontaneous imitative behaviour that is natural to human beings, consistency belongs to rational thinking and therefore to the dialectic of enlightenment. Thus, for Adorno, the opposition between mimetic content and aesthetic form creates the artistic continuum lying between authenticity and rationalisation that we have previously explored.

As we have already seen, with the exception of the works that Adorno takes to exemplify either end of the continuum, most artworks actually consist of a combination of rationality and mimesis, which might be thought of as opposing poles *within* each work.

- The rational pole of an artwork is its logical consistency, accomplished through form. Form is the determinant of a work's significance, partly because it is through form that 'artworks seek to become artworks' (Adorno, 1984: 308). Indeed, 'form is the law of the transfiguration of the existing, counter to which it represents freedom' (Adorno, 1984: 143). Conversely, in an unfree society, art that is formless becomes non-art, becomes 'raw and crude', and loses its ability to protest (Adorno, 1984: 143). This might be read as Adorno's anticipation of the exhaustion of the strategies of provocation of the neo-avantgarde, which consisted in testing the limits of what is counted as art with ever more extravagant violations of bourgeois taste, but led to a mausoleum of dead objects devoid of expressive qualities.
- The mimetic pole of the artwork is its likeness to something from empirical reality, accomplished through its subject-matter, or content. Artistic contents arise from mimetic impulses in relation to something in the external

world, that something about which the work awakens new feelings and perceptions. Consequently, content includes artistic sublimation of unconscious impulses and the aesthetic registration of socio-historical questions, gathered around the fundamental stimulus of a drive to imitate existing things (for instance, a stretch of land, a landscape painting, a star chart, a diagram of constellations). At the level of content, artworks are indeed 'plenipotentiaries of sublimated sensual impulses', linked to imitated things (Adorno, 1984: 11). But Adorno makes it clear that he does not intend by this that content is exclusively unconscious, merely that it arises *in connection with* the unconscious.

Early on in *Aesthetic Theory*, Adorno describes his fundamental position as a confrontation between Kant (formal consistency) and Freud (sublimated contents), on the terrain of a divergent dialectical theory (Adorno, 1984: 8–12). For both Kant and Freud, art is about desire, and therefore human happiness, but Adorno's prohibition on images of final reconciliation entails that 'art's promise of happiness means not only that hitherto practice has blocked happiness, but that happiness is beyond praxis' (Adorno, 1984: 12 translation modified). Art is desirous, always pointing beyond what exists, which is why it is fundamentally linked to negation – that is, to social criticism and the anticipation of reconciliation.

It is important to analytically differentiate between the material/technique and the form/content distinctions. Kiefer's rehabilitation of painterly materials through 'historical distressing' and 'alchemical purification', and his technique of symbolic accumulation through contrary combinations, only becomes the content of *Heaven on Earth* when brought into contact with some subject-matter. Although the basic subject-matter of that painting is 'scapes' (land- and star-), a multiplicity of stimuli is operating in *Heaven on Earth*, including the history of totalitarianism in a series

of 'fields', and a personal relation to reflective experiences guided by the Merkabah allegory of an ascent to heavenly palaces in the chariot of meditation. To bring out how sublimated drives find expression in Kiefer's work is beyond the scope of this discussion; what can be said is that the content of the work is permeated by emotional ambivalence (hope and despair, fascination and loathing) and conceptual antinomies (spirit and matter, freedom and domination). This internal division arises because the work is 'about' a historical redemption that must remain in question, partly on account of the history of symbolic art, including figurations of 'scapes', in the very domination that art seeks to escape, or at least, to problematise.

For Adorno, form is nothing but 'the sedimentation of content' (Adorno, 1984: 139), the logically consistent and aesthetically coherent expression of a position on a particular subject-matter, using certain historical materials and artistic techniques. Accordingly, there is a dialectical entwinement of aesthetic form with content (Adorno, 1984: 140), something that Kiefer's work exemplifies. Formally speaking, for reasons already discussed, *Heaven on Earth* revives the conventions of high-horizon, linear perspective landscape painting. Yet, as the unusual perspective that organises the identifying plaques suggests, this dominant form is complicated by a subordinate form, that of low-horizon night sky painting. Kiefer says that when he paints on the floor of his studio, the works have no definite orientation (Celant, 2007: 336); the secret to *Heaven on Earth*, I suspect, is that turning it upside-down inverts the relation between dominant and subordinate perspectives in the work. Formal dissonance is emblematised in jagged wire that splits the work and extends beyond its borders. Aside from its symbolic implications, then, the barbed wire literalises the clash of opposed forms in the work, releasing two distinct themes that Kiefer has also worked on in other pieces. These are that, as we have seen, 'you cannot have an innocent representation of a

landscape', and that there is always 'trouble on the way to paradise' (Celant, 2007: 295, 337).

The ambivalent content, doubling of perspective and dissonance of form in Kiefer's work, at the same time as an evident drive toward unity, clarify something in Adorno that might otherwise appear perplexing: the category of 'coherence' in relation to modernist artworks. Because modernism aggravates the tendencies to open forms that existed before modernism, Adorno speaks of the 'coherence' of open forms as the consistency with which they exploit their internal antagonisms into formal disjunction (Adorno, 1984: 142). This includes the determinate negation of meaning – for instance, in Beckett's plays (Adorno, 1984: 153). Accordingly, despite open form and negated meaning, works retain coherence. Indeed, Adorno's notion of formal coherence includes closed *and* open forms. A closed form is a dynamic totality in which the relation of the parts to one another and to the whole, and the connection between the total conception and the elaboration of details, is a harmonious accord or organic totality. An open form is one in which the relation of the parts to one another and to the whole, and the elaboration of the details within the total conception, includes antagonism and tension. But 'no artwork is without its own coherence' (Adorno, 1984: 127).

Coherence anticipates reconciliation, because it is the unforced unity of the diverse in a manner that catalyses reflexive judgement (an imaginative sort of cognition dealt with below) and that expresses historical truth. Modernist dissonance, the suspension of closed form, happens because the artworks' nonviolent synthesis of contradictory impulses precludes the coercion of particulars into the general conception of the work. Formal coherence 'is the nonviolent synthesis of the diffuse that nevertheless preserves it as what it is in its divergences and contradictions, and for this reason form is actually an unfolding of truth' (Adorno, 1984: 143).

Artistic significance and political impact

Adorno claims that 'the truth content of artworks is the objective solution to the enigma posed by each and every one...[which] can only be achieved by philosophical reflection' (Adorno, 1984: 128). Adorno's conception of truth content as conveyed by the mute particularity of modernist artworks and unfolded by philosophical reflection is twofold, because it connects to social reconciliation and to artistic progress. The key is Hegel, for whom art is the highest expression, in the medium of figuration, of the historical development of the consciousness of freedom in an epoch. But art, because it is figuration, cannot itself disclose the truth it tells about the social evolution of an expanded and deepened understanding of freedom, without becoming conceptual discourse (i.e., philosophy). Although each and every artwork of an era tells the same underlying story, the greatest artworks penetrate with absolute clarity to the heart of the contradictions of their epoch, and it is these artworks that advance both aesthetics and reflection upon social freedom. For instance, although the Greek tragedies of Aeschylus, Sophocles, Euripides and many lesser playwrights are lodged within and reflect upon the ancient Athenian conception of freedom, for Hegel, only Sophocles' *Antigone* raises this to the threshold of a new awareness through its subject-matter and formal structure. Adorno, as Zuidervaart notes, 'wears Hegel's glasses without sharing his view of world history' (Zuidervaart, 1991: 115): *all* modernist artworks speak of the strangulation of creative praxis by alienated labour and the totalitarian history that this implies; but, only *some* raise this to the level of explicit thematisation, in the context of artistic breakthrough. *Each* of them requires the mediation of philosophical aesthetics to release this truth content from artistic particularity into propositional discourse. In a way, however, they all express the same truth:

The new is the longing for the new, not the new itself: that is what everything new suffers from. What takes itself to be utopia remains

the negation of what exists and is obedient to it. At the centre of contemporary antinomies is that art must be and wants to be utopia, and the more utopia is blocked by the real functional order, the more this is true; yet at the same time, art may not be utopia, in order not to betray it by providing semblance and consolation. If the utopia of art were fulfilled, it would be art's temporal end. Hegel was the first to realise that the end of art is implicit in its concept... Hegel's theory that the world spirit has sublated art as a form is contradicted by another theory of art to be found in his work, which subordinates art to an antagonistic experience that prevails against all affirmative philosophy... Art is no more able than theory to concretise utopia, not even negatively. A cryptogram of the new is the image of collapse; only by virtue of the absolute negativity of the collapse does art enunciate the unspeakable: utopia... Through the irreconcilable renunciation of the semblance of reconciliation, art holds fast to the promise of reconciliation in the midst of the unreconciled. This is the true consciousness of the age in which the real possibility of utopia... converges with the possibility of total catastrophe. (Adorno, 1984: 32–33)

The artist's objectification of the experience of a threatened subjectivity, through innovation in the materials and techniques, mimetic content and dissonant form, discloses historical antagonisms within the social formation. Yet this response necessarily also provides an instance of how under liberated social conditions, the ego would be capable of integrating psychic impulses without resorting to repression. In order not to betray this promise of happiness into an escapist consolation, however, the beautiful illusion that the artwork represents must appear ripped down the middle. But even this is a reminder of the potential for creative praxis and mimetic conduct, as opposed to alienated labour and instrumental rationality.

Nonetheless, 'every work is the mortal enemy of the other' (Adorno, 1984: 211). That means: every now and again, along comes a work that sweeps all of the others into their graves. For although all of the works speak the same truth, they do not all

tell it the same way, or as well. This is what Adorno means by artistic 'import', or 'significance', an idea that combines the idea of the work's *importance* with that of its *signification*. As far as importance goes, Adorno is emphatically not announcing a rank ordering of contemporary works, for he insists that the import of a work only emerges retrospectively, through the way that it inescapably sets problems for its successors, and especially, through the way that these problems are insoluble for the vast majority of artists (Adorno, 1984: 211–12). In terms of signification, each work responds in a particular way to specific aspects of historically existing social reality. Ultimately, though, the deepest works will be those that respond to the central problem of the modern world, the opposition between the true universal, the 'principle of individuation' and the false universal, the principle of universal equivalence. 'The *principium individuationis*, which implies the need for the aesthetically particular, is not only universal as a principle in its own right, it is inherent in the self-liberating subject...and not lodged beyond the particular individuals who bear it' (Adorno, 1984: 200). Thus, the significance of the most individuated artworks is that they exemplify 'the dialectical postulate that the particular is the universal, [which] has its model in art' (Adorno, 1984: 202). Here is the real concrete totality, the true image of reconciliation, in a society of autonomous individuals, consisting of individuated particulars which are at the same time exemplars of the universal.

Adorno connects this to the cognitive claims of the work of art. Because creative praxis on the basis of mimetic conduct transcends alienated labour on the basis of instrumental rationality, Adorno proposes a dialectic of discursive (scientific) knowledge and non-discursive (artistic) knowledge under capitalism (Zuidervaart, 1991: 202). He critically adapts a point made by Kant, that discursive knowledge relies on determining judgement, the faculty of classification which subsumes particular cases under universal rules. By contrast, art relies on

reflexive judgement, which as we have seen is the ability to seek or invent universal principles on the basis of particular cases, based on their status as exemplary. Adorno's point is that scientific knowledge that is unfertilised by artistic particulars *cannot possibly* imagine any society other than the current arrangements (because it lacks contact with creative praxis and therefore has no access to socio-cultural alternatives) and so *must necessarily* adopt an ideological stance toward the existing order (Adorno, 1984: 163–66). As Zuidervaart summarises Adorno's position, 'Artistic truth content... is the materialisation in artworks of the most advanced consciousness of contradictions, within the horizon of their possible reconciliation' (Zuidervaart, 1991: 116).

Art is therefore socially explosive, provided that it maintains its independence. Adorno's opposition to 'politically committed' artworks springs from this perception. Whereas autonomous artworks gesture toward a radical transformation of social arrangements, militant statements of political commitment clad in an aesthetic form generally only manage local social criticism. In the process, their reduction of art to a useful function (political propaganda) completely eliminates the betrayed promise of happiness that truthful artworks are capable of expressing. For Adorno, political impact flows from artistic significance and not the other way around, for 'truth content always points beyond the immanent aesthetic make-up of artworks toward political significance' (Adorno, 1984: 243). Modernist artworks by figures such as Samuel Beckett, Adorno argues, raise radical questions that go deeper than militant figures such as Berthold Brecht.

Although a critic such as Peter Bürger is satisfied by Adorno's argument that committed art loses aesthetic validity and becomes ideologically ineffective political propaganda, he questions the aesthetic strategy behind Adorno's defence of modernism. For Bürger, interwar modernism and the avantgarde (and postwar

modernism and the neo-avantgarde), must be distinguished, for while modernists such as Kandinsky and Kiefer propose a renewal of perception through a radicalisation of art, the (neo-)avantgarde wants to explode the institution of art altogether. The Surrealists in particular wanted to destroy the separation between art and everyday life, which led them to a series of counter-aesthetic strategies designed to generate anti-art. Bürger grasps this as the direct opposite of modernist strategies, which have the effect of protecting the institutional separation of art and everyday life. From the perspective of the avantgarde, Bürger argues, modernism is actually a *conservative* force, which aims to preserve a reified distinction that condemns art to ineffective protest even as it safeguards its own independence.

Bürger's attack echoes a line of self-doubt that Adorno himself expresses throughout *Aesthetic Theory* (e.g., Adorno, 1984: 234), that artworks represent a complicit critique of commodity society. But as Adorno notes, the anti-art experiment of the avantgardes broke the frames of the artworks without releasing the truth content of autonomous art into everyday life at all, because the society itself was left completely unchanged. Equally, the apparently democratic announcement that everybody is an artist because anything can count as art – that is, a counter-aesthetic strategy of de-forming artworks – completely misfired. 'The demolition of the difference between the artist as aesthetic subject and the artist as empirical person attests to the abolition of the distance of the artwork from the empirical world, without, however, art thereby delivering a world of freedom' (Adorno, 1984: 253). Surrendering the difference between art and the world, the artist and everybody, in the absence of social transformation, means abdication of critical distance, which in reality implies renunciation of all resistance to the culture industry.

Bürger's response is that although the avantgarde failed as a whole, Adorno has not accepted the historical implication of the effort itself. The avantgardes have destroyed

the possibility that a given school can present itself with the claim to universal validity ... The meaning of the break in the history of art that the historical avantgarde movements provoked does not consist in the destruction of art as an institution, but in the destruction of the possibility of posing aesthetic norms as valid ones. (Bürger, 1984: 87)

The project of the neo-avantgarde is to exploit this opening. In other words, we should be talking about 'art after Duchamp', not 'art after Auschwitz', and we should be doing so from a nominalist position; that is, from the perspective that there is absolutely nothing intrinsic to art objects – not even aesthetic form – that separates artworks from things in general (Bürger, 2010: 707–714). According to Bürger, then, the neo-avantgarde exposes the truth that what counts as art is an institutional question decided by discursive relations and power complexes in the art world.

Adorno anticipates this line of criticism in *Aesthetic Theory*, in relation to aleatory works, avantgarde happenings, action painting and noise music. His reply is that aesthetic nominalism scarcely bothers to conceal the resignation at its heart, the idea that capitalism, together with the commercialised and bureaucratised art world, is the only game in town. This involves a sort of bad faith: 'the aesthetic subject exempts itself from the burden of giving form to the contingent material it encounters ... and instead shifts the burden of responsibility back onto the material itself'. Yet, Adorno notes, 'nominalistic artworks constantly require the intervention of the guiding hand they conceal in the service of their principle' (Adorno, 1984: 221), which minimally forms them through the act of selection. Accordingly, nominalist aesthetic strategies are dominated by the arbitrary will of the author (instead of a confrontation with the material) and by a literal-mindedness that is not unlike the dominant mindset in the surrounding society. 'Unchecked aesthetic nominalism,' Adorno suggests, 'terminates in a literal facticity – and this is

irreconcilable with art' (Adorno, 1984: 220). This is a devastating rejoinder to positions like that of Bürger. Adorno's hostility to fake radicalism springs from political realism, not from secret conservatism: 'if art is capable of realizing its humane universality at all, then it is exclusively by means of the rigorous division of labour – anything else is false consciousness' (Adorno, 1984: 235).

Chapter 4

Adorno today

Adorno's defence of modernism is nothing less than an 'aesthetic redemption of modernity' (Wellmer, 1991: 1). Although Adorno regards the potentials of the modern world as highly ambivalent, modernity does nonetheless contain an emancipatory impulse, in the form of autonomous art and dialectical philosophy. Both art and philosophy bring rationality into connection with mimesis in a way that prevents them from becoming engines of instrumental reason. Outside of these forms of resistance, the administered world involves the crushing of individuality, the potential for political authoritarianism and an utterly meaningless culture. Accordingly, aesthetic semblance, the artistic illusion, carries the hope of reconciliation within modernist artworks, in the form of a protest at the broken promise of happiness. Autonomous art, with its individuated contents and dissonant forms, at once gestures toward reconciliation and indicates that the world makes it impossible. Philosophy interprets this as art's truth content, deploying its dialectical methodology to critically denounce the historical conditions of unfreedom that betray modernism's representation of utopia. Armed with dialectical knowledge of the limitations of instrumental reason and engaged in a liberating practice with a socially transformative intent, the modern individual can dare to hope for a better world.

How relevant is Adorno's demanding philosophy today? Perhaps we should not ask ourselves what we think of Adorno, but consider instead what he would think of us. The confidence with

which most commentators announce that Adorno is *passé* would, to Adorno, have evidenced a waning of utopian energies and a slackening of critical tension that is flabby, and sad. There is a lot of critical resignation around, and nowhere more so than in the commonsense assumption that with the 'triumph of capitalism' at the end of the Cold War, all talk of social alternatives is a mere embarrassment. Against any sort of quiet acceptance of the status quo, Fredric Jameson proposes that rather than regarding Adorno's perspective as dated, we should consider it untimely. 'Adorno's prophesies of the 'total system' finally came true…in the postmodern landscape', so that 'Adorno's Marxism…may turn out to be just what we need today' (Jameson, 1990: 5). In a similar vein, radical philosopher Slavoj Žižek comments that 'in *Dialectic of Enlightenment*, Adorno and Horkheimer had the right insight; I agree with their formal procedure, but as for the positive content, I think it's a little bit too light[!!]' (Rassmussen, 2007: Žižek cited). Žižek is one of the few to really grasp Adorno's aesthetic strategy for presenting philosophical ideas, of 'let's paint the ultimate outcome of the administered world as unavoidable, as catastrophe, for this is the only way to effectively counteract it'. This is hardly surprising, for Žižek adopts the same device himself, because he holds, with Adorno, that 'the fundamental feature of today's society is the irreconcilable antagonism between Totality and the individual' (Žižek, 2008: 127). As his editors comment, 'Žižek's open-ended, non-teleological conception of dialectics is indebted – though he seldom acknowledges it – to Adorno' (Butler and Stephens, 2005: 357).

It has to be said, however, that none of the Adorno-influenced philosophers and critics who affirm the 'actuality of Adorno' is a doctrinaire 'Adornian', for all regard themselves as licensed by Adorno himself to engage critically and appropriate selectively. The refreshing thing about Adorno's anti-systematic philosophy is that it does not produce acolytes: at worst, its enigmatic density generates academic commentators; at best, its contradictory

fragments spark highly original, independent positions. Along these lines, it is entirely reasonable to ask how some of Adorno's key aesthetic ideas are travelling, in light of some major developments that have happened in the forty-plus years since his death. The changes relevant to Adorno's position to be explored in this chapter are:

- The advent of a new relation between the mainstream and the artworld, signified by the term 'the postmodern condition', in which, supposedly, 'art, finally, becomes absorbed into the culture industry of the capitalist economy, reduced to a pseudo-autonomous pseudo-life' (Wellmer, 1991: 87).
- The emergence of second-wave feminism in the 1970s, as a movement which deepened first-wave feminism's demands for equality into a critique of the masculine standard supposed to determine what individuals were intended to be equal to.
- The philosophical turn to language in the second half of the twentieth century, as a means to get away from exclusive reliance on subject-object models of thinking that are patterned, not on dialogue between subjects, but on human beings' manipulation of the natural environment.

Although every one of these developments resonates with Adorno's general approach, each of them also poses a potential challenge to the relevance of Adorno's specific formulations. If the postmodern condition truly exists in the ways it is normally represented, then autonomous art is finished, and there can be no redemption of the emancipatory potential of modernity. Advocates of postmodernity advise thinkers influenced by Adorno to abandon nostalgia for the lost hope of a liberation from the modern condition that springs from the internal contradictions of modernity itself. Contemporary feminism seldom agrees with postmodern theory that the age of emancipation is over, but it has

pointedly questioned the universality of such abstractions as 'the subject' and 'the individual'. Feminist art critics have not been slow to draw the implication that the struggle for individuation in resistant forms of women's art cannot be recruited to a generalised conception of reconciliation without further discussion. But the category of reconciliation itself has seemed problematic to Adorno's successors in the Frankfurt School. Jürgen Habermas and Albrecht Wellmer argue that utopian reconciliation is mortgaged to a Romantic opposition between reason as instrumental manipulation and mimesis as an alternative to the concept. If reason is mainly a linguistically-mediated social phenomenon that emerges in dialogue, then instrumental forms are a small subset of rationality that should not be represented as annexing the whole of reason, whether as triumph or catastrophe. That would place art in a very different relation to rationalisation than the one envisaged by Adorno.

Popular culture and the postmodern condition

Schönberg is the fixed star in Adorno's firmament. By contrast, the lesser luminescences – Stravinsky, Webern, Berg and Hindenmith – revolve in seeming confusion. The movement of Stravinsky, who rotates 180° in Adorno's estimate, appears particularly perplexing. In *Philosophy of Modern Music* (1947), Stravinsky is the negative inverse of Schönberg's positive breakthrough. Where Schönberg's compositional constructions rationalise music in a progressive way, Stravinsky's symphonic montage expresses only to a reactionary longing with fascist connotations. Yet in 'Stravinsky: A Dialectical Portrait' (1962), Adorno changes his position, reversing his evaluation of Stravinsky. Without retracting his critique of Stravinsky's early work, Adorno now takes into account the late work, which prompts Adorno to lend critical support to the composer's objectified expression of the alienated society. What seemed before like fascist collectivism now appears as subversive parody under desperate conditions:

Suddenly (after Stravinsky's most anti-individualist work, *The Rite of Spring*) he must have perceived the hopeless situation of all music: how was music which had emancipated itself from all established reference systems to achieve a coherence based purely on its own inner resources? To do him justice, it has to be observed that to this day, it has remained uncertain whether total emancipation can bring about the objectivisation of art and hence make art itself possible in a society which provides the artist with nothing by way of substantial, valid forms. …Stravinsky's objectivism is just as powerful a testimony to alienation as is the sound of pure interiority in Webern. (Adorno, 1998: 162–63)

The late Adorno's treatment of the final Stravinsky describes his art as pastiche – the juxtaposition of quoted fragments drawn from popular culture and modernist art, without any coordinating principle to establish a hierarchy of value – and positions this on the terrain of blank parody. The art is parodic of the things it cites, precisely because its generalisation of pastiche suggests that it is ultimately a mimesis of the flattening of all distinctions of quality under the force of universal equivalence. Reflecting the collapse of a clear distinction between modernist art and the culture industry through the fragmentation of aesthetic materials – the heterogeneous and immiscible fragments that make up a pastiche composition – Stravinsky's late work protests the eclipse of the cultural conditions that make autonomous art possible.

For many commentators, the advent of postmodern culture from (at latest) the 1960s onwards has seemed to destroy the credibility of Adorno's modernism. The idea of the postmodern is, of course, contested terrain, but it seems to refer to a whole series of intellectual and cultural developments that rule out Adorno's argumentative strategy, of political migration into autonomous artworks. Following Hans Bertens' balanced presentation of the question, the major characteristics of postmodern intellectual perspectives and cultural practices are as follows.

- *Intellectually*, a decisive rejection of totality and universality. In line with French philosopher Jean-

François Lyotard's influential argument, postmodern culture arrives at the moment of the 'end of master narratives', which basically means, the exhaustion of the idea of progress. The concepts of social fragmentation and moral-political regression, used by progressives (e.g., socialists, feminists and liberals) to diagnose the problems of modern society, depend upon background assumptions about wholeness and rightness for their intelligibility. By recasting society as a discrete series of heterogeneous language games, totality goes out the window. When language games clash, what happens is dissensus, not a new consensus on a higher universality. Thus, totality can only mean totalitarian unification of the social field through the coercive imposition of a fake universal that suppresses difference.

• *Culturally*, postmodernism is characterised by the effacement of the frontier between high art and popular culture, which supposedly ruins the modernist strategy of separating autonomous art from the culture industries. Modernist works often quoted popular culture satirically as a means to ironically distance themselves from standardisation, through contrasting their own high stylistics with commercial clichés. Postmodernist works operate through techniques of pastiche, as mentioned, a (visual, cinematic or literary) collage practice in which material fragments of popular culture and past modernist works are juxtaposed together without authorial commentary or ironic distance. This partly responds to the academic canonisation and commercial acceptance of modernism, which indicates that no work stands entirely outside the field of commodity production. Andy Warhol's work, often consisting of accurate reproductions of commercial art, is often taken to exemplify postmodern practices.

The perceptive reader will already have noticed that neither of these developments actually collapses Adorno's position. In the first place, Adorno is firmly opposed to the authoritarian implications of the real totality of the administered society and the coercive implications of universal equivalence. 'Totality is not an affirmative but a critical category,' Adorno writes. 'A liberated mankind would by no means be a totality' (Adorno, 1976a: 12).

In the second place, postmodernism would be, from Adorno's late perspective, the 'Stravinskyisation' of the artworld. This would of course be potentially problematic for Adorno, because once this gesture becomes routinised, as we saw in the previous chapter, the risk is that the distinction between the universe of the artwork and empirical reality collapses. The line between a final protest and a delirious celebration of the pseudo-liberation of art from the responsibility to imagine a better world, the distinction between blank parody and uncritical affirmation, is perilously fine.

Most standard introductions to postmodern culture do not even bother to pause at the vanishing moment of desperate protest. With breathtaking hypocrisy, they sail straight from the 'end of metanarratives' to a big story about how with the advent of New Times, everything has changed for the better. Along these lines, the literary critic Ihab Hassan, strongly influenced by Lyotard, provides the classic description of the difference between modernism and postmodernism (based on Hassan, 1982: 269):

Modernism	Postmodernism
Form (conjunctive, closed)	Antiform (disjunctive, open)
Purpose	Play
Design	Chance
Hierarchy	Anarchy
Mastery/Logos	Exhaustion/Silence
Art object/Finished work	Process/Performance/Happening
Distance	Participation
Creation/Totalisation	Decreation/Deconstruction

Hypotaxis	Parataxis
Lisible (readerly)	Scriptible (writerly)
Narrative/Grande histoire	Antinarrative/Petit histoire
Genital/Phallic	Polymorphous/Androgynous
Paranoia	Schizophrenia
Universal/Centred	Difference/Decentred
Metaphysics	Irony
Determinacy	Indeterminacy

One feels like asking rhetorically: hands up all those who would like to produce a closed, phallic, hierarchically logocentric narrative totalisation in the form of a finished work claiming a determinate metaphysics?

Thoroughly Oedipal in its structure, Hassan's list of binary oppositions secretes an unreflexive moral distinction between 'bad' authority and 'good' rebellion, which it superimposes onto the modernism/postmodernism distinction in order to prejudice the question in advance. This master opposition aligns a series of other, potentially loaded oppositions in the list: totalisation and deconstruction; hierarchy and anarchy; centring and dispersal; determinacy and indeterminacy. By constructing equivalence between closure, totality and hierarchy as against openness, deconstruction and anarchy, the 'neutral' list takes on the status of a concealed axiology. Hassan's list, in other words, is not just a register of formal features, but a 'practical taxonomy' in the sense lent this expression by the sociologist Pierre Bourdieu: a series of oppositions that naturalise practice on the basis of a moral binary, 'good' versus 'bad'.

From the perspective of Adorno-influenced cultural critic Fredric Jameson, the most interesting characteristic of Hassan's advocacy of postmodern culture is its principled opposition to totality and universality, combined with a resolute refusal to discuss the capitalist totality and universal equivalence operating within and around the artworld. Jameson interprets this as repression, in the Freudian sense, of knowledge that is known but

unwelcome, which generates a complete re-naturalisation of the cultural conditions caused by late capitalism. He argues that postwar capitalism from 1945 onwards entered a new phase of development beyond state monopoly capitalism, involving a culture of consumption and the development of multinational corporations. For Jameson, postmodern culture, which he characterises in terms of the commodification of aesthetic materials, techniques of pastiche, a loss of the feeling of alienation and a 'schizophrenic' (unhistorical) consciousness, is a product of the consequent increase in reification. With the incorporation of advertising into product design and the rise of multinational entertainment corporations, there has been a 'prodigious expansion of culture throughout the social realm' and the complete commodification of 'those...precapitalist enclaves (Nature and the Unconscious) which offered extra-territorial and Archimedean footholds for critical effectivity' (Jameson, 1991: 48–49). The result is a cultural practice in the field of high art that is the opposite of modernism, for where modernism 'cited' materials to parody them, postmodernist citation of popular culture is 'amputated of the satiric impulse, devoid of laughter...blank parody, a statue with blind eyeballs' (Jameson, 1991: 17).

While Jameson's debt to Adorno is evident – his description of postmodern culture borrows extensively from Adorno's discussions of Stravinsky – what is less obvious is the extent to which his stance correlates with Adorno's basic approach. Jameson is not normally regarded as a 'bleak pessimist', but in Adorno's terms, a position that affirms the total reification of nature and the unconscious is hopelessly despairing. It effectively rules out resistance to that administered society which Jameson, following Adorno, detects in the contemporary world (Jameson, 1990: 5). From Adorno's perspective, nature (and therefore the unconscious) is ineradicable, which means that there is a permanent potential for resistance to commodification that autonomous art is capable of expressing, if its practitioners decide to defend it.

Let us grant, then, that Jameson's critical practice shows how Adorno's work still has traction in postmodern culture, along the lines of postmodernism as 'Stravinskyisation'. The question remains of whether a grim 'end of autonomous art' perspective is really the only way in which Adorno's contribution to contemporary debate can be interpreted. David Roberts argues compellingly in *Art and Enlightenment: Aesthetic Theory after Adorno* (1991) that postmodernism emerges as ironic negativity after the decline of the myth of progress, and that Adorno's reading of Stravinsky points the way forward in contemporary criticism (Roberts, 1991). Another way to go would be to focus on the fragmentation of aesthetic materials and the eclipse of a clear frontier between the artworld and the culture industry. Intuitively, there is an enormous difference between, for instance, the cinematic realism of Ridley Scott's *Sanctum* (2008), the dissonant modernism of Lars von Trier's *Anti-Christ* (2009) and the delirious postmodernism of David Lynch's *Inland Empire* (2006). The idea that 'everything is postmodern now' is a night in which all cows are gray: a coarse generalisation lacking in descriptive plausibility. Interwar modernism relied on the complete separation of high art and mass culture: they were two warring islands. Now the artworld and popular culture occupy a single landmass that is divided by a shifting and porous frontier. But the effacement of a frontier, or 'end of the great divide between autonomous art and mass culture' (Huyssen, 1986), is not the same as the elimination of the two poles at either end of a continuum. It is not only that reports of the death of late modernism are somewhat exaggerated, as Kiefer's art demonstrates. It is also that whatever their aesthetic strategies, postmodern works just simply do not sit in the same field as Hollywood blockbusters, Coca-Cola billboards, Dan Brown novels and Kandinsky reproductions. The artistic standardisation of cultural industry products is not the same as the aesthetics of pastiche of postmodern practices. What this shift in perspective

highlights is that postmodernism is not a fact of nature, but one aesthetic strategy selected from several, by some – perhaps a majority – in the artworld. This is backed by an ideological chorus line of critics, whose business it is to persuade the audience that there is no alternative to uncritical affirmation of the existing arrangements.

Nor should we reify postmodernism into a monolith. For Adorno, the permanent potential for resistance means that the practice of pastiche can be articulated in progressive and regressive directions. Adorno's affirmation of the resilience of the expressive subject connects with his somewhat convoluted use of the term 'authentic art', in the context of a discussion in *Aesthetic Theory* of 'blank parody' in postwar culture. It appears that for Adorno, 'authenticity' (i.e., a nostalgic regression to supposed naturalness) is different from 'authentic art' (i.e., a serious art of engagement with aesthetic problems capable holding truth content):

> The dividing line between authentic art that takes on itself the crisis of meaning and a resigned art consisting literally and figuratively of protocol sentences is that in significant works the negation of meaning takes shape as a negative, whereas in the others the negation of meaning is stubbornly and positively replicated. Everything depends on this: whether meaning inheres in the negation of meaning in the artwork or if the negation conforms to the status quo; whether the crisis of meaning is reflected in the works, or whether it remains … alien to the subject. (Adorno, 1984: 154)

But how to decide whether a pastiche of materials – which is what Adorno means here by 'the negation of meaning' – has the status of negation or affirmation? Adorno believes that the key to this lies in the peculiar aesthetic coherence of works based on the principle of what he calls 'montage'. for 'artworks that negate meaning must necessarily be disrupted in their unity; this is the function of montage, which disavows unity through the emerging disparateness of the parts, at the same time that, as a principle of

form, it affirms unity' (Adorno, 1984: 154). Now, montage (i.e., pastiche) as a technique 'negates meaning' because the raw inclusion of social facts (found objects) is a mere presentation of things rather than a representation of their perception by the subject. But montage, as a principle of coherence 'once again asserts the semblance of meaning', provided that it is not the tired repetition of a gesture whose shock value has expired. It does so when it elevates the idea of the historically created lack of fit between parts and whole to the organising idea of the work itself (Adorno, 1984: 155–56). In other words, when montage/pastiche is a *deliberate artistic commentary on aesthetic content*, signified through formal self-reflexivity and the historicisation of the materials, it becomes potentially subversive. For instance, in the field of literature, the Adorno-inspired literary critic Paul Maltby identifies Donald Barthelme, Robert Coover, William Burroughs, Don Delillo, Kathy Acker, Ishmael Reed and Thomas Pynchon as 'dissident postmodernists'. Centrally, fragmented forms based on pastiche techniques are explicitly historicised within literary history and related to the situation of literary aesthetics in society (Maltby, 1991: 37–42). The dissident postmodernists employ postmodern literary techniques (mainly pastiche) to achieve a de-naturalisation of perception through exposing the historical character of ideological representations and the constructed nature of perceptions. Nonetheless, the sort of complicit critique staged by postmodern aesthetics cannot be assimilated to Adorno's notion of autonomous art: dissident postmodernism and dissonant modernism remain competing alternatives in the contemporary artworld.

Although the charge that Adorno is irrelevant to postmodern culture is completely unfounded, there certainly are problems with his treatment of popular culture – but we should be careful not to overstate them. In *Roll Over Adorno: Critical Theory, Popular Culture, Audiovisual Culture* (2006), Robert Miklitsch maintains that Adorno is 'absurdly out of touch with the times' (Miklitsch,

2006: 44). According to Miklitsch, Adorno remains parasitically dependent on a homogenised image of mass culture for a straw man, against which to rehabilitate autonomous art long after it has ceased to be popularly effective (Miklitsch, 2006: 195). Adorno 'stands for European high culture and all things classical, including and especially music[al culture]', in opposition to a supposedly debased popular culture in which he can locate no emancipatory impulse (Miklitsch, 2006: xviii). That means that Adorno is blind to the counter-hegemonic forces at work in popular culture – emblematically, Adorno overlooks Anton Schönberg's 'wild dialectical other', Chuck Berry, whose 'Roll Over Beethoven' slams the nail into the lid of high culture's coffin.

The rhetorical élan of Miklitsch's critique leads him to simplify Adorno's position instead of seeking to grasp its limitations through an analysis of its complexity. In 'The Culture Industry Reconsidered' (1975), based on a radio interview in the last years of his life and published posthumously, Adorno points out that the accusation of elitism springs from a misfired democratic impulse that conflates 'mass culture' – that is, the spontaneous culture of the popular majority – with the 'culture industries', the standardised products of entertainment corporations (Adorno, 1991: 98). Adorno and Horkheimer deliberately changed the terminology of their drafts of *Dialectic of Enlightenment* from 'mass culture' to 'culture industry' to avoid this mistake, because the 'rebellious resistance' in popular culture is precisely what the culture industry hopes to reduce to 'behaviour patterns that are shamelessly conformist' (Adorno, 1991: 99, 103). Nonetheless, the dialectical truth in Miklitsch's critique is that although Adorno has the conceptual resources to differentiate popular cultures of resistance on the margins of commercial entertainment, from standardised culture-industrial products, in the end, Adorno doesn't look nearly hard enough.

What Adorno particularly despises is what he calls 'light entertainment' haloed with pretensions to be autonomous art, and

his case studies are commercial European and American 'jazz', radio-programmed classical music and the televisation of realist novels (Adorno, 1991: 29–60, 128–77). Jazz must be rendered in mocking quotation marks because Adorno 'frequently classifies *all* nonclassical music as jazz, evidently based on the dubious belief that jazz was the dominant and paradigmatic form of popular music in his lifetime' (Grackyk, 1992: 527). When he does talk about jazz as we know it, Adorno is mainly concerned with the swing era of jazz (approximately 1933–41), during which even his critics accept that 'at that time most popular bands relied on stock arrangements and downplayed genuine improvisation' (Grackyk, 1992: 533; corroborated by Robinson, 1994: 16). Nonetheless, Charlie Parker (pre-swing), Billie Holliday (swing) and Miles Davis (post-swing) are all important jazz artists in Adorno's lifetime, who cannot possibly be accused of musical conformity, and with whom he never came to grips. Most probably the reason for this is that Adorno in exile on the wrong side of the United States and then in return to Germany relied extensively on two books by American commentators that were written in the 1930s from a limited musicological perspective (Harding, 1995: 131). But the fact remains that Adorno never learnt to listen to jazz, falsely homogenised the movement and then ignorantly wrote it off as a whole. Indeed, even though Adorno, using the vocabulary of his own day and not ours, recognises 'the authentic Negro elements in jazz', he thinks that 'everything unruly in it was from the very beginning integrated into a strict scheme' by white musical entrepreneurs (Adorno, 1967a: 122). Thus, he ethnocentrically neglects the contribution of anti-commercial, resistant forms of African-American popular culture to the jazz movement, in which context his critique of what he supposes is tokenism is liable to bleed into a sort of cultural denigration that Adorno would certainly not have consciously endorsed (see Harding, 1995: 137–38).

It is crucial to understand that Adorno's critique of jazz is not based on its commercial status but on its aesthetic value. Adorno

singles out jazz for criticism because unlike openly standardised commercial popular songs, the practice of improvisation purports to reject standardisation and resist conformity. Accordingly, his strategy is to demonstrate that: (1) jazz is 'regressive listening' that involves 'pseudo-individuation' of derivative aesthetic materials drawn from popular songs (Adorno, 1991: 55–56); and (2), even when jazz avoids a monotonous beat, popular song-forms and tonal harmonies, its formal innovations do not burst the envelop of development marked out by Brahms (Adorno, 1967a: 123). Adorno sums up the case for pseudo-individuation and conventionality:

Jazz is a form of manneristic interpretation … (I)nstead of jazz itself being composed, 'light music,' the most dismal product of the popular-song industry, is dressed up … (and) what appears as spontaneity is in fact carefully planned out with machinelike precision. But even where there is real improvisation … the sole material remains popular songs. Thus, the so-called improvisations are reduced to the more-or-less feeble rehashing of basic formulas (that) conform to norms and recur constantly. (Adorno, 1967a: 123)

Not only are these are falsifiable claims in principle – they are demonstrably false in fact. Jazz musicians such as Charlie Parker did not mainly rely on popular songs, but when they did, the effect of his negations of commercial hits is to produce something 'disturbing, in the same way that some of Schönberg is disturbing' (Grackyk, 1992: 532 critic cited from 1930s). When they did not, the point was *performance*, not *composition*, because the individuation in jazz improvisation depends on the expressive spontaneity of the transient moment, not the method of rational construction in the written notation. Furthermore, the developments from ragtime, through swing to bop and then into postwar free jazz, exhibit exactly the sort of learning process through aesthetic experimentation that Adorno describes as a developmental sequence in *Aesthetic Theory*.

What all of this suggests is that Adorno's main concern is not high art versus popular culture, but market-driven commercial

products versus new forms of aesthetic expression (Jay, 1973: 182). The (in-principle correctable) problem is that he did not get to grips with experimental forms of popular culture using his own aesthetic theories, and so missed an opportunity to intervene in the cultural politics of the mass reception of art. Beginning from Jameson's important essay on 'Reification and Utopia in Mass Culture' (1977), a whole series of Adorno-inspired critics has sought to identify developmental sequences in popular culture that break free from commercial standardisation and commence experimentation. Greil Marcus and Simon Frith (in the sociology of music), Oskar Negt, Thomas Andrea, Miriam Hansen and Peter Wollen (in cinema studies), Douglas Kellner, Herbert Schiller and Armand Mattelart (in media studies) and many others, have effectively proposed the following. Autonomous art is not a thing – it is a process of differentiation from commercial standardisation that expresses resistance, but may be recuperated; in other words, it is a political struggle. Political migration, far from being outdated, may be the best way to understand the most interesting trends in popular culture today.

Adorno and feminism

In its efforts to get beyond essentialist thinking about gender differences, contemporary feminism in the English-speaking world has been particularly influenced by French post-structuralist philosophy, and especially the method of deconstruction developed by Jacques Derrida. Nonetheless, Adorno's negative dialectical categories are regarded as an important resource by some feminist thinkers, and this is hardly surprising, as he has been described in a qualified way as the Marxist Derrida. Adorno performs a materialist critique of identitarian classifications and of the reification of cultural differences as supposedly natural essences that is reminiscent of deconstruction (Dews, 1986). Adorno's relevance to feminism springs from his insistence on how the particularity of experience resists reduction into universal

concepts, combined with his criticism of how instrumental reason naturalises the desire for mastery by generating the 'identical, purpose-directed, masculine character of [modern] human beings' (Adorno and Horkheimer, 2002: 26). In other words, Adorno genders the universal and links this to oppression in a way that unequivocally connects (historically determined and culturally constructed) masculinity to domination.

For present purposes, feminism can be concisely defined as a movement that 'encourages the public expression of gendered and sexual oppression and suffering to accomplish the ends of recognition and justice' (Heberle, 2006: 217). Although the elimination of economic inequality, the end of political discrimination and the abolition of the cultural denigration of women are amongst the demands of the movement, Renée Heberle pointedly refuses to define the ultimate goals of feminism in terms of equality. That is because an important component of the feminist critique of masculine domination involves questioning the naturalness and justness of the way in which the universality of what it is to be human gets culturally defined in terms of the characteristics of 'Man'. What this means is that the very standard by which one might measure what equality is – how two individuals are 'the same', according to some salient quality – must be thoroughly interrogated and reconstructed, before it can be relevant to the claims of justice.

Adorno is not a feminist. Nonetheless, in *Minima Moralia*, he maintains that gender differences between masculine and feminine are asymmetrical within the 'masculine liberal competitive economy', which means that the 'feminine character' becomes a 'negative imprint of domination' (Adorno, 2005: 92). What Adorno means by this is that women are constrained by the process of socialisation to internalise the ideological stereotype that equates femininity with nature and masculinity with culture. This positions women as men-that-lack: Woman as something less than the full humanity of Man; femininity as an

entry into rational, masculine culture that is retarded by a certain excess of naturalness, instinctiveness, emotionalness and so forth. Vehemently criticising this, Adorno asserts that 'the Femininity which appeals to instinct is always exactly what every woman has to force herself by violence – masculine violence – to be: a she-man' (Adorno, 2005: 95). For Adorno, under these conditions, and in the absence of a transformation of social arrangements, the full participation of women in society merely means equal-opportunity access to complete dehumanisation – a dehumanisation, he insists, that in reality is defined by men. As Lisa Yun Lee sums up:

Adorno comes startlingly close to naming Woman as the 'second sex'. Simone de Beauvoir, of course, does so in her work *The Second Sex*, where she describes the ontological process whereby 'man' defines himself through a hierarchical contrast with an 'Other' that is 'woman'. Mapping the Hegelian master-slave dialectic onto male-female relations, de Beauvoir shows how 'man' assumes a universalistic position in this formulation, whereas 'woman' is doomed to the contingent and subordinate status of the 'second sex' ... de Beauvoir goes on to claim that the price men pay for representing the universal is a kind of loss of embodiment, whereas the price that women pay is an immanent existence defined by her confinement to the body. Men are disembodied and gain entitlement to transcendence, and women are embodied and consigned to immanence. These are two asymmetrical corporeal situations that Adorno recognises. Adorno acknowledges that disembodied, affect-free epistemological systems privilege the 'wholly autonomous, narcissistic *male* ego' and that Woman represents the 'Other' to this masculine-gendered way of knowing. However ... the feminine in Adorno's reading is an otherness that consistently disrupts the totalising concept of masculinity, which pathologically asserts itself over bourgeois society. Kate Soper concisely sums it up this way: 'The whole is not masculine, and feminine negativity surfaces as the immanent refusal and critique of this supposed "truth"'. This is what Adorno means when he describes the 'feminine character' as 'a negative imprint of domination'. (Yun Lee, 2006: 129)

According to Heberle, the negativity of femininity is released through the experiences of individual women, and especially, through the articulation of suffering flowing from the material particularity of the body, which Adorno maintains is the condition of possibility for truth. 'Freedom flows from the resistant subject's self-expression,' Adorno claims, for the 'need to give voice to suffering is the condition of all truth. Suffering is objectivity that weighs down the subject' (Adorno, 1966: 27; Adorno, 1973: 17–18). The whole, the universal, is the false: the individual, the particular is the truth of the false totality, emerging through an experience that resists assimilation to the classifying schemas of the reigning universal concepts. As we have already seen in chapter one with Adorno's negative dialectics, experience does not go into the concept without a remainder, whose persistent negativity testifies to particular qualities overlooked by the universal. This takes the form of contradictions within the systems of identity thinking:

Experience forbids the softening, in the unity of consciousness, of its stumble across contradiction. For instance, a contradiction such as the one between the definition that an individual has of themselves and the one forced upon them by society – their 'role' – cannot, without manipulation, without some impoverished umbrella term, be made to vanish. (Adorno, 1966: 153; Adorno, 1973: 152)

The experience of suffering through the inadequacy of role definitions is captured in feminist artist Cindy Sherman's film stills from the 1970s. As with postmodern art, Sherman performs a complicit critique of aesthetic traditions in the representation of women, especially women in conventional domestic or feminine roles. In her *Film Still #2* (1977), for instance, Sherman has photographed herself draped in a bath towel and admiring her reflection, in which she strikes a pose that hesitates between sexual provocation and revealing naivety. The photograph solicits responses that have to do with the visual pleasure aroused by representations of women's bodies – that is, after all, what she herself is partly doing

in the mirror – without endorsing these responses through Sherman's own self-objectification. As Mary Caputi notes, Sherman here produces a subversive work, where 'the voyeuristic motif reconfirms traditional readings of gender', but 'the image's profound uncertainties and internal ruptures allow it to work against those readings, and to allude to gender's frailty' (Caputi, 2006: 312). Thinking with and against Adorno, Caputi concludes: 'the deeper subject of Sherman's feminist performance art is not the female body variously presented, but the instability of "woman" as a cultural category;…her art underscores the body's unstable meanings and gender's extreme tenuousness even as it replays society's efforts to mark femininity as stable' (Caputi, 2006: 309).

Yet the notion of experience that is grounded in the body as resistance to the dominion of the universal also highlights some of Adorno's limitations. The existence of these limitations justifies the claim that despite the potential fertility of his thought for feminism, Adorno's own relationship to feminism is highly equivocal on some points.

There is an interesting story behind this, known in the German scene as the 'bared-breasts incident', or *der Busenaktion*, in which female student activists stormed the podium at one of Adorno last lectures, proclaimed that 'Adorno as an institution is dead!' and bared their breasts at him. 'Baring their breasts was a direct challenge to his masculinity and aimed at exposing the impotence of theory,' Yun Lee writes; the professor departed 'speechless, ashamed and flustered' (Yun Lee, 2006: 115). According to legend, the cleavage commotion finished Adorno off, or, at least, catalysed his heart failure some weeks later. More plausibly, 'Adorno's inability to directly confront the corporeal specificity of the situation is revealing,' because 'the body that Adorno championed in his theoretical prose is not the equivalent of the unruly bodies of those female students' (Yun Lee, 2006: 115).

Probably the deepest conceptual source of this difficulty is the way Adorno's commitment to a dialectical form of autonomy,

both for art and the individual, is framed. Certainly, Adorno is critical of Kant's idealist concept of autonomy as the monologue of reason performed by the isolated and disembodied transcendental subject. Against this, he interprets the transcendental subject in materialist terms as the dynamic equilibrium of an ego, id and superego ensemble at the heart of every individual. But Adorno's intention to 'break through, with the power of the subject, the fallacy of constitutive subjectivity' (Adorno, 1966: 8; Adorno, 1973: xx) – that is, to rupture the idealist unity of subject and object – means that he is committed to recasting autonomy in Freudian terms.

For Freud, independence arises as a consequence of the successful resolution of the Oedipus Complex in both men and women, which, for our purposes, means that autonomy springs from rebellion against paternal authority. As Juliet Mitchell has demonstrated in her detailed and critical investigation of psychoanalysis, Freud is not the anti-feminist patriarch that popular misconceptions take him to be. Freud's most controversial (and misunderstood) idea is that both masculine and feminine sexuality are generated by the encounter between highly plastic sexual drives and the psychic representation of the father's dominance and potency. This representation of paternal power is concentrated in the image of the phallus, and the individual's confrontation with this symbol of authority and fertility is fateful for their sexuality. That, as Mitchell says, 'is not a recommendation *for* a patriarchal society, but an analysis *of* one' (Mitchell, 1974: xv). This coincides with Adorno's interpretation of Freud, for 'psychoanalysis in its most authentic and by now already obsolete form comes into its own as a report on the forces of destruction rampant in the individual amidst a destructive society' (Adorno, 1967b: 95). Social destructiveness, as we have seen, centres on masculine domination. Nonetheless, by identifying, along with Freud, the locus of political and sexual authority in the socialisation process with the actual father in the domestic

environment, Adorno commits himself to a qualified defence of just that bourgeois nuclear family which many feminists regard as the most significant institutional force for women's oppression.

In her critique of *Minima Moralia*'s ethics, Eva Geulen pursues the implications of Adorno's position on the family and the body through an analysis of his idea that love must redeem rage in order to create a reconciled society (Geulen, 2006). Adorno identifies the survival instinct leading to self-preservation with the aggressive drive and believes that this is the root of idealist philosophy, domineering universals and reified systems (Adorno, 1966: 31–32; Adorno, 1973: 22–23). Against hate is ranged the power of natural affection whose ultimate core is sexual ecstasy, which, as love, exemplifies the 'power to see similarity in the dissimilar' that Adorno links to discovering the universal in the particular without reducing the heterogeneous to identity (Adorno, 2005: 191). According to Adorno, 'only he who could situate utopia in blind somatic pleasure, which, satisfying the ultimate intention, is intentionless, has a stable and valid idea of truth' (Adorno, 2005: 61). Sexual love as a 'blissful tension' involves satisfying the other in satisfying oneself, which implies a sort of intentionless intentionality that Adorno associates with the deliberate uselessness of art and the anti-instrumental validity of truth.

Now, the problem is this. On the one hand, sexual-romantic love is an accomplishment of post-Oedipal socialisation, because (according to Freud), individuals learn to love the extra-familial other through the process of internalising the full implications of the prohibition on incest. Like the autonomy advocated by Adorno, sexual-romantic love is therefore the product of a rebellion against paternal authority. As the culture industries erode paternal authority in the family household during the twentieth century, Adorno claims to detect a tendency to project archaic images of the father onto political leaders, as individuals who lack the independence that rebellion produces seek support against their own impulses in external social authorities.

With the family there passes away, not only the most effective agency of the bourgeoisie, but also the last resistance which – though repressing the individual – also strengthened, perhaps even produced him. The end of the family paralyses the forces of opposition. The rising collectivist order is a mockery of the classless... Utopia. (Adorno, 2005: 23)

Such a 'collectivist', 'fatherless' society is a regular Brave New World of loveless copulation and authoritarian manipulation, potentially sundered from realistic prospects for developing the natural affection between individuals that might provide a social alternative.

On the other hand, the bourgeois family is, as Adorno parenthetically concedes, a form of domination and the locus of the psychic repression that Freud identifies as the source of the 'discontents of civilisation'. Although not exactly nostalgic for nineteenth-century forms of paternal authority (Comay, 2006: 56), Adorno has no replacement for it either. This is a real double-bind in his thinking, which generates a knot of equivocal statements on the 'castrated' character of the culture industries (Adorno, 1967a: 129) and the 'homosexual' inability to love of modern individuals (Adorno, 1967b: 96). Is there, as Rebecca Comay suggests, an anxious, unconscious investment in maintaining sexual difference at work here (Comay, 2006: 43)? Or, as Geulen proposes, does Adorno's underlying belief in the oedipal structuration of desire lead him ultimately *away* from Eros and into the arms of Freud's Nirvana Principle, the death drive, which pushes Adorno to represent reconciliation as stasis (Geulen, 2006: 107)? Or is it the case, as Yun Lee implies but does not say, that *der Busenaktion* had its humiliating effect only because its addressee had, after all and unbeknownst to himself, an anxious, unconscious investment in male potency? Whatever the answer, the questions converge on a single conclusion: feminism cannot uncritically appropriate Adorno's notion of individuality.

Philosophy after Adorno

As Habermas, Adorno's former research assistant, says, Adorno 'produced an irresistible critique of the bourgeois individual, and yet he was himself caught in its ruins' (Habermas, 1983: 103). Habermas's highly influential philosophical project can be understood as an effort to constructively criticise some of Adorno's key concepts while vigorously asserting the continued relevance of the problems that he raises. The massive two volumes of Habermas's *Theory of Communicative Action* [1981] essay two basic responses to the question of how to prolong the emancipatory intentions of Adorno's redemption of modernity, without becoming entangled in the theses of the total system of instrumental reason and the disintegration of the bourgeois individual.

Habermas's notion of communicative action clarifies the subject-subject rationality of dialogue (or 'intersubjectivity') in terms of the development in the modern world of the distinct strands of scientific, moral and aesthetic reason. These are opposed to instrumental reason and provide a liberating alternative to it, without needing to propose that rationality can only be emancipatory when linked to mimesis. From the perspective of Habermas's defence of autonomous art, modernism is progressive because it articulates the logic of the discovery of new perceptions and feelings, together with new cultural values, through experimental art. Habermas insists that ego maturity is a better standard than the idea of natural affection before or beyond oedipal socialisation, for evaluating the individual's development of independence. Adorno's cured Freudian individual who is nothing more than a 'hungry beast of prey' in an unreconciled society makes no sense if the maturity of the ego means the individual's growth beyond cultural conformity. Habermas's mature individuals are committed, as defining characteristics of their maturity, to the perspectives of the modern scientific rejection of religious mystification and political ideologies, to moral autonomy in the context of social solidarity, and to the

experimental perspectives of modern art and the affirmation of a plurality of lifestyles. Together, these two positions yield a vision of modernity that is significantly open, as opposed to the closure of the 'administered world' (Habermas, 1987: 345–99).

Prolonging this approach into an encounter with Adorno's aesthetics, Wellmer proposes that artworks are media of communication before they are models of reconciliation (Wellmer, 1991: 21). Artworks represent worlds of possible experience as aesthetically unified wholes, where Habermas's three dimensions of scientific truth, moral rightness and subjective truthfulness are simultaneously present. The 'truth potential' of an artwork is linked to its claim to aesthetic validity and depends upon 'the complex relationship of interdependence between the various dimensions of truth in the living experience of individuals, in the formation and transformation of attitudes, modes of perception and interpretations' (Wellmer, 1991: 27). Artworks, then, do not bear truth content, but a truth potential that can only be unlocked through the integration of aesthetic experience into the everyday lives of individuals and their subsequent raising of new claims to scientific truth, moral rightness and subjective truthfulness (Wellmer, 1991: 28). Nonetheless, this communicative experience indicates a possible reconciliation, not in the form of a return to the mimetic roots of all thinking, but in the form of the anticipation of an open communication community where science, morality and art would no longer be systematically blocked by the imperatives of instrumental reason (Wellmer, 1991: 29).

Habermas and Wellmer's constructive criticisms are extremely cogent. Adorno's entire conception of both mimetic and instrumental reason is based on the subject-object relation. He completely overlooks the subject-subject relation of intersubjective communication, which leads him to radically downplay the communicative aspect of art and the emancipatory moment in dialogue. From this perspective, Adorno's formulations of the ideal of reconciliation are hopelessly Romantic. According to both

Habermas and Wellmer, for Adorno, 'the realm of communicative behaviour that exists outside the territory of conceptual thought is mimesis' (Wellmer, 1991: 13). They are concerned that this is a new version of the old Romantic-irrationalist opposition between (oppressive) reason and (liberating) nature. They are also worried about the idea of thinking in contradictions inherent to negative dialectics. For Adorno, the total critique of reason by means of reason leads up to the affirmation of logical contradiction as a component of truth, but for Habermas, that sounds like an elementary indication that something has gone wrong with the argument. But what all of this means is not that Adorno is junk. Instead, it means that Adorno's formulations must be corrected in light of recent philosophical developments.

At the same time, the ecological focus of Adorno is now more relevant than ever before. Indeed, the ideal of reconciliation to the environment that Adorno promoted is absent or under-developed in Habermas and Wellmer. The mutual correction of theses is a two way street: it is not a question of a condescending treatment of Adorno's 'mistakes' and 'limitations'. Adorno's intention, as we have seen, is not to oppose reason and mimesis, but to explore their subterranean interconnection in the act of judgement that informs perception. Adorno's claim is that identity thinking and aesthetic mimesis spring from the human being's spontaneous relation to the natural environment: the problem is a history of instrumental rationality that represses the mimetic core of all thinking and opposes art to (traditional) philosophy. The state of reconciliation is not a condition of pure natural mimesis, but one in which the balance between forms of thinking has been restored, whereupon the need for negative dialectical reason vanishes. This balanced interaction between the various moments of rationality is not unlike the ideal of an open communication community, except that it emphasises ecological balance as an essential component of human happiness, in a way that language-based theories do not.

The utopian impulse in contemporary thinking must not be lost. Adorno's concern with reconciliation in modernist artworks springs fundamentally from his affirmation of the importance of human happiness. In the context of a problematic development of modernity, this means a principled defence of the right of suffering to have a voice, for in the expression of indignation at injustice, Adorno detects the desire for utopia. In modifying some of Adorno's potentially monolithic social-theoretical theses on the administered world by expanding the conception of reason, we must not lose sight of the principle of hope, which, as Adorno so eloquently proposes, alone gives knowledge and art its meaning.

Further reading

Adorno is a challenging and provocative read, but well-translated new editions with excellent introductions based on constructive interpretations of his thought make this less daunting than before. There is a host of recent scholarship on Adorno, including several very fine general introductions that cover his contributions to philosophy, sociology, cultural criticism and aesthetics. The best general introduction is Simon Jarvis, *Adorno: A Critical Introduction* (1998), while Alex Thompson, *Adorno: A Guide for the Perplexed* (2006), provides an excellent entry point for those coming to Adorno for the first time. Martin Jay, *Adorno* (1984), is highly critical but very accessible, and surveys Adorno's major positions in ways that offer a serviceable map of the territory. Both Susan Buck-Morss, *The Origins of Negative Dialectics* (1977), and Gillian Rose, *The Melancholy Science* (1978), provide illuminating discussions of Adorno's relation to Benjamin and Hegel, respectively. Fredric Jameson, *Late Marxism* (1990), interprets rather than explicates Adorno, but with considerable force and plausibility. Hauke Brunhorst, *Adorno and Critical Theory* (1999), positions Adorno in his major philosophical contexts, while Martin Jay, *The Dialectical Imagination* (1973), and David Held, *Introduction to Critical Theory* (1980), locate Adorno in the global project of the Frankfurt School. Rolf Wiggershaus, *The Frankfurt School* (1994), is the full-length standard introduction to the Frankfurt School for scholarly purposes, and Detlev Claussen,

Theodor W. Adorno: One Last Genius (2008), is the most important biography for research ends. The contributions to Thomas Huhn, *The Cambridge Companion to Adorno* (2004), are of a uniformly excellent quality and shed light on everything from Adorno's *Tom Sawyer* operetta to his relation to Kant's *Critique of Pure Reason*. Likewise, the contributions to Robert Hullot-Kentor's *Things beyond Resemblance* (2006) are all highly informative and illuminate the whole of Adorno's work.

The most impressive constructive project influenced by Adorno in the English language is without doubt that of J.M. Bernstein, whose *Adorno: Disenchantment and Ethics* (2001) and *Against Voluptuous Bodies* (2006) are astonishing (though demanding) reflections on the implications of Adorno for ethics and aesthetics, respectively. Yvonne Sherratt, in *Adorno's Positive Dialectic* (2002), essays an important reconstruction of Adorno's relation to Freud in terms that are lucid and controlled. Brian O'Connor's *Adorno's Negative Dialectic* (2005) provides a systematic account of Adorno's relation to the German philosophical tradition, and Lambert Zuidervaart's *Social Philosophy after Adorno* (2007) is an extended meditation on the philosophical implications of Adorno's central reflective contributions. Shierry Weber Nicholsen's *Exact Imagination, Late Work* (1997) reads Adorno's aesthetics with great precision and insight, while Lambert Zuidervaart's *Adorno's Aesthetic Theory* (1991) is simply invaluable as a reconstruction of the logic of Adorno's most difficult work. David Roberts' *Art and Enlightenment* (1991) argues a superbly dialectical perspective on postmodern art as self-reflexive modern art, along lines controlled by Hegel and Adorno. Deborah Cook's *The Culture Industry Revisited* (1996) is a subtle and serious presentation of Adorno's cultural theory, and Max Paddison's *Adorno's Aesthetics of Music* (1993) is an outstanding introduction to his musicology. Albrecht Wellmer's *The Persistence of Modernity* (1991) is an excellent example of an Adorno-influenced critical

engagement with Habermas, inflected in the Habermasian direction, whereas J.M. Bernstein's *Recovering Ethical Life* (1995) is a sustained and urgent, Adorno-inspired critique of Habermas. Max Pensky's collection, *The Actuality of Adorno* (1997) is a sophisticated set of high-level reflections on Adorno and contemporary intellectual culture.

References

Adorno, Theodor (1966). *Negative Dialektik*. Frankfurt am Main: Suhrkamp.

Adorno, Theodor (1967a). *Prisms*. Cambridge, MA: MIT Press.

Adorno, Theodor (1967b). 'Sociology and Psychology (Part Two).' *New Left Review* 1(47): 79–97.

Adorno, Theodor (1973). *Negative Dialectics*. London: Routledge.

Adorno, Theodor (1976a). 'Introduction.' *The Positivist Dispute in German Sociology*. Theodor Adorno, Ed. London: Heinemann.

Adorno, Theodor (1976b). *Introduction to the Sociology of Music*. New York: Seabury.

Adorno, Theodor (1977). 'The Actuality of Philosophy.' *Telos: A Quarterly Journal of Critical Thought* 31: 120–32.

Adorno, Theodor (1981). *In Search of Wagner*. London: Merlin.

Adorno, Theodor (1984). *Aesthetic Theory*. London: Routledge and Kegan Paul.

Adorno, Theodor (1991). *The Culture Industry*. London and New York: Routledge.

Adorno, Theodor (1992). *Notes to Literature*, Volume 2. New York: Columbia University Press.

Adorno, Theodor (1998). *Quasi una Fantasia: Essays on Modern Music*. London; New York: Verso.

Adorno, Theodor (2000). 'The Essay as Form.' *The Adorno Reader*. Brian O'Connor, Ed. Oxford; Malden, MA: Blackwell: 91–111.

Adorno, Theodor (2002). *Essays on Music: Theodor W. Adorno*. Berkeley, CA: UCLA Press.

Adorno, Theodor (2005). *Minima Moralia: Reflections from Damaged Life*. London: Verso.

Adorno, Theodor (2007a). 'Commitment.' *Aesthetics and Politics*. Fredric Jameson, Ed. London; New York: Verso: 177–95.

Adorno, Theodor (2007b). *Philosophy of Modern Music*. London; New York: Continuum.

Adorno, Theodor and Max Horkheimer (2002). *Dialectic of Enlightenment: Philosophical Fragments*. Stanford, CA: Stanford University Press.

Bernstein, J.M. (2001). *Adorno: Disenchantment and Ethics*. Cambridge: Cambridge University Press.

Bloch, Ernst (2007). 'Discussing Expressionism.' *Aesthetics and Politics*. Fredric Jameson, Ed. London; New York: Verso: 16–27.

Bronner, Stephen Eric (1983). 'Emil Nolde and the Politics of Rage.' *Passion and Rebellion: The Expressionist Heritage*. Stephen Eric Bronner and Douglas Kellner, Eds. South Hadley, MA: JF Bergin Publishers: 293–309.

Buchloh, Benjamin (1981). 'Figures of Authority, Ciphers of Regression: Notes on the Return of Representation in European Painting.' *October* 16: 39–68.

Buchloh, Benjamin (2001). *Neo-Avantgarde and Culture Industry: Essays on European and American Art from 1955 to 1975*. Cambridge, MA: MIT Press.

Buck-Morss, Susan (1977). *The Origin of Negative Dialectics: Theodor W. Adorno, Walter Benjamin and the Frankfurt Institute*. New York: The Free Press.

Bürger, Peter (1984). *Theory of the Avant-Garde*. Minneapolis: University of Minnesota Press, 1984.

Bürger, Peter (2010). 'Avant-garde and Neo-avant-garde.' *New Literary History* 41: 696–715.

Butler, Rex and Scott Stephens (2005). 'Glossary.' *Interrogating the Real*. Rex Butler, Scott Stephens et al, Eds. London; New York: Continuum: 356–74.

Caputi, Mary (2006). 'Unremarked and Unrehearsed: Theodor Adorno and the Performance Art of Cindy Sherman.' *Feminist Interpretations of Theodor Adorno*. Renée Heberle, Ed. University Park, PA: Pennsylvania State University Press: 301–21.

Celant, Germano (2007). *Anselm Kiefer*. Milan: Skira.

Claussen, Detlev (2008). *Theodor W. Adorno: One Last Genius*. Cambridge, MA; London: Harvard University Press.

Comay, Rebecca (2006). 'Adorno's Siren Song.' *Feminist Interpretations of Theodor Adorno*. Renée Heberle, Ed. University Park, PA: Pennsylvania State University Press: 41–68.

Dews, Peter (1986). 'Adorno, Post-structuralism and the Critique of Identity.' *New Left Review* 157: 28–44.

Distel, Barbara and Ruth Jukusch, Eds. (1978). *Concentration Camp Dachau, 1933–1945*. Brussels: Comité International de Dachau.

Freud, Sigmund (1984). *On Metapsychology*. London: Penguin.

Freud, Sigmund (2001a). *The Standard Edition of the Complete Psychological Works of Sigmund Freud, Volume XIV (1914–1916): On the History of the Psycho-Analytic Movement, Papers on Metapsychology and Other Works*. London: Vintage.

Freud, Sigmund (2001b). *The Standard Edition of the Complete Psychological Works of Sigmund Freud, Volume XIX (1923–1925): The Ego and the Id and Other Works*. London: Vintage.

Freud, Sigmund (2001c). *The Standard Edition of the Complete Psychological Works of Sigmund Freud, Volume XXI (1927–31): The Future of an Illusion, Civilization and its Discontents, and Other Works*. London: Vintage.

Geulen, Eva (2006). '"No Happiness without Fetishism": Minima Moralia as Ars Amandi.' *Feminist Interpretations of Theodor Adorno*. Renée Heberle, Ed. University Park, PA: Pennsylvania State University Press: 97–112.

Gödde, Christoph and Thomas Sprecher, Eds. (2006). *Theodor Adorno and Thomas Mann: Correspondence 1943–1955*. London: Polity.

Grackyk, Theodore (1992). 'Adorno, Jazz and the Aesthetics of Popular Music.' *The Musical Quarterly* 76(4): 526–42.

Habermas, Jürgen (1983). 'Theodor Adorno: The History of Subjectivity – Self-affirmation Gone Wild.' *Political-Philosophical Profiles*. Jürgen Habermas, Ed. London: Heinemann: 99–109.

Habermas, Jürgen (1984). *The Theory of Communicative Action: Reason and the Rationalisation of Society*. Boston, MA: Beacon Press.

Habermas, Jürgen (1987). *The Theory of Communicative Action: System and Lifeworld*. Boston, MA: Beacon Press.

Habermas, Jürgen (1989). *The New Conservatism: Cultural Criticism and the Historians' Debate*. Cambridge, MA: MIT Press.

Harding, James (1995). 'Adorno, Ellison, and the Critique of Jazz.' *Cultural Critique* 31(2): 129–58.

Hassan, Ihab (1982). *The Dismemberment of Orpheus: Toward a Postmodern Literature*. New York: Oxford University Press.

Heberle, Renée (2006). 'Living with Negative Dialectics: Feminism and the Politics of Suffering.' *Feminist Interpretations of Theodor Adorno*. Renée Heberle, Ed. University Park, PA: Pennsylvania State University Press: 217–32.

Held, David (1980). *Introduction to Critical Theory*. Berkeley, CA: UCLA Press.

Horkheimer, Max (1974). *Eclipse of Reason*. New York: Seabury Press.

Horkheimer, Max (1982). *Critical Theory: Selected Essays*. New York: Continuum.

Huyssen, Andreas (1986). *After the Great Divide: Modernism, Mass Culture, Postmodernism*. Bloomington, IN: Indiana University Press.

Huyssen, Andreas (1989). 'Anselm Kiefer: The Terror of History, The Temptation of Myth.' *October* 48: 25–45.

Huyssen, Andreas (1992). 'Kiefer in Berlin.' *October* 62: 84–101.

Jameson, Fredric (1979). *Fables of Aggression: Wyndham Lewis, the Modernist as Fascist*. Berkeley, CA: University of California Press.

Jameson, Fredric (1990). *Late Marxism: Adorno, Or, The Persistence of the Dialectic*. London and New York: Verso.

Jameson, Fredric (1991). *Postmodernism, Or, The Cultural Logic of Late Capitalism*. Durham, NC: Duke University Press.

Jay, Martin (1973). *The Dialectical Imagination*. Boston, MA; Toronto: Little, Brown & Co.

Jay, Martin (1984). *Adorno*. London: Fontana.

Kandinsky, Wassily (1970). *Concerning the Spiritual in Art*. New York: George Wittenborn.

Kellner, Douglas (1983). 'Expressionism and Rebellion'. *Passion and Rebellion: The Expressionist Heritage*. Stephen Eric Bronner and Douglas Kellner, Eds. South Hadley, MA: JF Bergin Publishers: 3–40.

Kennedy, Michael and Joyce Kennedy, Eds. (2007). *The Concise Oxford Dictionary of Music*. Oxford: Oxford University Press.

Kester, Miriam (1983). 'Kandinsky: The Owl of Minnerva.' *Passion and Rebellion: The Expressionist Heritage*. Stephen Eric Bronner and Douglas Kellner, Eds. South Hadley, MA: JF Bergin Publishers: 250–72.

Lukács, György (1963). *Die Eigenart des Ästhetischen*. Neuwied: Luchterhand.

Lukács, György (1964). *Essays on Thomas Mann*. London: Merlin.

Lukács, György (1970). 'Art and Objective Truth.' *Writer and Critic, and Other Essays*. Arthur Kahn, Ed. London: Merlin: 25–60.

Lukács, György (1971). *History and Class Consciousness*. London: Merlin.

Lukács, György (1980). *The Destruction of Reason*. London: Merlin Press.

Lukács, György (2007). 'Realism in the Balance.' *Aesthetics and Politics*. Fredric Jameson, Ed. London; New York: Verso: 28–59.

Lyotard, Jean-François (1974). 'Adorno as the Devil.' *Telos: A Quarterly Journal of Critical Thought* 19: 127–37.

Maltby, Paul (1991). *Dissident Postmodernists: Barthelme, Coover, Pynchon*. Philadelphia, PA: University of Pennsylvania Press.

Mann, Thomas (1968). *Doctor Faustus*. London: Penguin.

Marcuse, Herbert (1968). *Negations: Essays in Critical Theory*. London: Penguin.

Marcuse, Herbert (1978). *The Aesthetic Dimension: Toward a Critique of Marxist Aesthetics*. Boston, MA: Beacon Press.

Marcuse, Herbert (1999). *Reason and Revolution*. Amherst, NY: Humanity Books.

Marx, Karl (1963). *Capital, Vol. 1*. Moscow: Progress Publishers.

Marx, Karl (1964). *The Economic and Philosophical Manuscripts of 1844*. New York: International Publishers.

Marx, Karl and Frederick Engels (1986). *Marx Engels Selected Works*. Moscow: Progress Publishers.

Miklitsch, Robert (2006). *Roll Over Adorno: Critical Theory, Popular Culture, Audiovisual Culture*. Albany, NY: SUNY Press.

Mitchell, Juliette (1974). *Psychoanalysis and Feminism*. Harmondsworth: Penguin.

Mitscherlich, Alexander and Margarete Mitscherlich (1975). *The Inability to Mourn: Principles of Collective Behaviour*. New York: Grove Press.

Paddison, Max (1993). *Adorno's Aesthetics of Music*. Cambridge: Cambridge University Press.

Rassmussen, Eric Dean (2007). 'Liberation Hurts: An Interview with Slavoj Žižek.' (Retrieved 1 September 2011, from http://www.electronic bookreview.com/thread/endconstruction/desublimation.)

Roberts, David (1991). *Art and Enlightenment: Aesthetic Theory after Adorno*. Lincoln, NA and London: University of Nebraska Press.

Robinson, Bradford (1994). 'The Jazz Essays of Theodor Adorno: Some Thoughts on Jazz Reception in Weimar Germany.' *Popular Music* 13(1): 1–25.

Rose, Gillian (1978). *The Melancholy Science: An Introduction to the Thought of Theodor W. Adorno*. London: Macmillan.

Saltzman, Lisa (1999). *Anselm Kifer and Art after Auschwitz*. New York; Cambridge: Cambridge University Press.

Schmidt, James (2004). 'Mephistopheles in Hollywood: Adorno, Mann and Schönberg.' *The Cambridge Companion to Adorno*. Thomas Huhn, Ed. Cambridge: Cambridge University Press: 148–80.

Schönberg, Arnold (2003). 'The Relationship to the Text.' *The Schoenberg Reader*. Joseph Auner, Ed. New Haven, CT: Yale University Press: 89–90.

Selz, Peter (1974). *German Expressionist Painting*. Berkeley, CA: UCLA Press.

Sherratt, Yvonne (2002). *Adorno's Positive Dialectic*. Cambridge: Cambridge University Press.

Weber, Max (1958). *The Rational and Social Foundations of Music*. Carbondale, IL: Southern Illinois University Press.

Weber Nicholsen, Shierry (1997). *Exact Imagination, Late Work: On Adorno's Aesthetics*. Cambridge, MA: MIT Press.

Wellmer, Albrecht (1991). *The Persistence of Modernity: Essays on Aesthetics, Ethics and Postmodernism*. Cambridge, MA and London: MIT Press.

Wiggershaus, Rolf (1994). *The Frankfurt School: Its History, Theories, and Political Significance*. Cambridge: Polity.

Yun Lee, Lisa (2006). 'The Bared-Breasts Incident.' *Feminist Interpretations of Theodor Adorno*. Renée Heberle, Ed. University Park, PA: Pennsylvania State University Press: 113–40.

Žižek, Slavoj (2008). In Defense of Lost Causes. London; New York: Verso.

Zuidervaart, Lambert (1991). *Adorno's Aesthetic Theory: The Redemption of Illusion*. Cambridge, MA: MIT Press.